Remembering Tampa

Ralph Brower

TURNER
PUBLISHING COMPANY

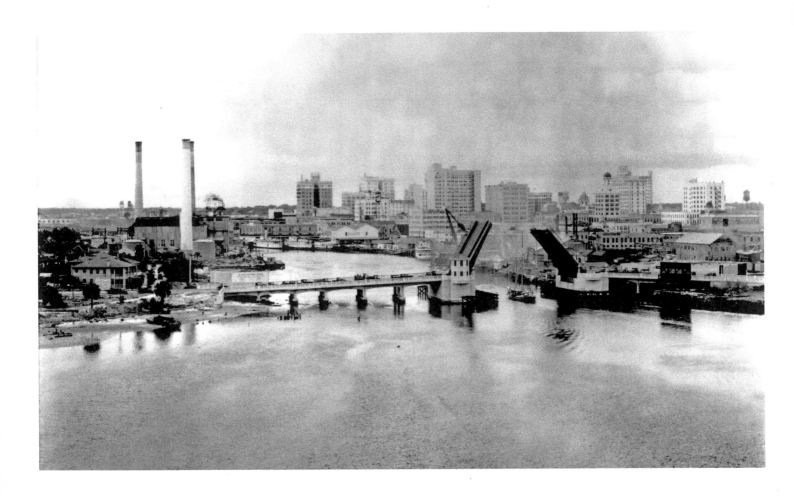

The Platt Street Drawbridge is raised as a vessel enters the Hillsborough River. The smoke stacks of Tampa Electric Company's Hyde Park plant rise on the left of the scene. This 1926 photograph was shot from the Tampa Municipal Hospital, which was under construction on Davis Islands.

Remembering
Tampa

Turner Publishing Company
www.turnerpublishing.com

Remembering Tampa

Library of Congress Control Number: 2010902285

ISBN: 978-1-59652-611-2

Printed in the United States of America

ISBN: 978-1-68336-888-5 (pbk.)

CONTENTS

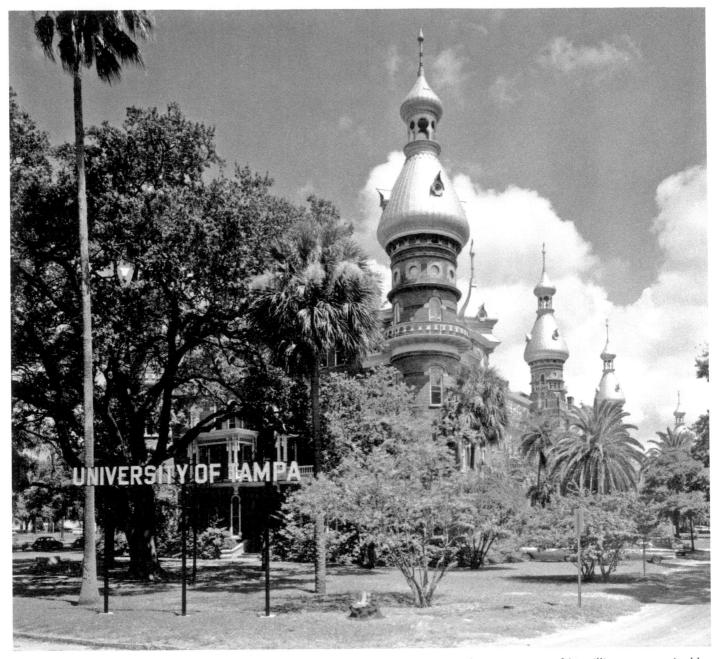

The magnificent Tampa Bay Hotel, which was built by Henry Plant between 1888 until 1891 at a cost of $3 million, was acquired by the City of Tampa in 1905 for $125,000. It stood mostly unused for nearly 30 years before the buildings and grounds were leased to the University of Tampa in 1933. Seen here in 1959, this is the entrance to the campus from Hyde Park Avenue.

ACKNOWLEDGMENTS

We would like to express our gratitude to Susan Brower for providing research assistance to the author and the contributing support throughout project.

We would also like to thank the following individuals and organizations for their valuable contributions and assistance in making this work possible:

Otis Anthony, Salatha Bagley, Canter Brown, Jr., Donald L. Chamberlain, Karl H. Grismer, Charles E. Harner, Charles E. Harrison, the Hillsborough County Planning Commission, Robert J. Kaiser, Karen McClure, Gary R. Mormino, Anthony P. Pizzo, R. L. Polk's City Directory of Tampa, George E. Pozzetta, *The St. Petersburg Times*, Bob Baggett Photography, and Tampa-Hillsborough County Public Library.

PREFACE

Tampa has thousands of historic photographs that reside in archives, both locally and nationally. This book began with the observation that, while those photographs are of great interest to many, they are not always easily accessible. During a time when Tampa is looking ahead and evaluating its future course, many people are asking, How do we treat the past? These decisions affect every aspect of the city—architecture, public spaces, commerce, tourism, recreation, and infrastructure—and these, in turn, affect the way that people live their lives. This book seeks to provide easy access to a valuable, objective look into Tampa's history.

The power of photographs is that they are less subjective than words in their treatment of history. Although the photographer can make subjective decisions regarding subject matter and how to capture and present it, photographs seldom interpret the past to the extent textual histories can. For this reason, photography is uniquely positioned to offer an original, untainted look at the past, allowing the viewer to learn for himself what the world was like a century or more ago.

This project represents countless hours of research and review. The researchers and writer have reviewed thousands of photographs in numerous archives. We greatly appreciate the generous assistance of the archivists listed in the acknowledgments of this work, without whom this project could not have been completed.

The goal in publishing this work is to provide broader access to a set of extraordinary photographs that seek to inspire, provide perspective, and evoke insight that might assist people who are responsible for determining Tampa's future. In addition, the book seeks to preserve the past with adequate respect and reverence.

The photographs selected have been reproduced in vivid black-and-white to provide depth to the images. With the exception of touching up imperfections that have accrued with the passage of time and cropping where necessary, no changes have been made. The focus and clarity of many images are limited to the technology and the ability of the photographer at the time they were recorded.

The work is divided into eras. Beginning with some of the earliest known photographs of Tampa, the first section records photographs from the 1870s through the end of the nineteenth century. The second section spans the beginning of the twentieth century to the end of World War I. Section Three moves from the 1920s to World War II. And finally, Section Four covers World War II to the 1950s.

In each of these sections we have made an effort to capture various aspects of life through our selection of photographs. People, commerce, transportation, infrastructure, religious institutions, educational institutions, and scenes of natural beauty have been included to provide a broad perspective.

It is the publisher's hope that in utilizing this work, longtime residents will learn something new and that new residents will gain a perspective on where Tampa has been, so that each can contribute to its future.

—Todd Bottorff, Publisher

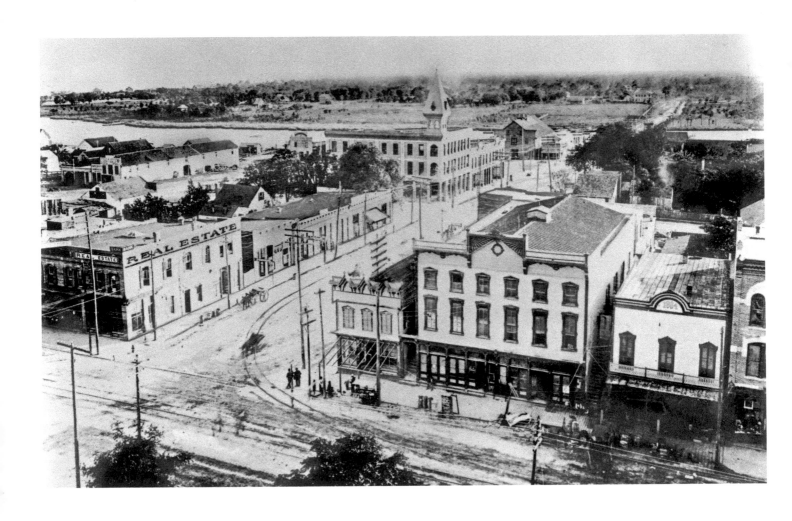

Intersection of Franklin and Lafayette streets, looking southwest across the river toward the area to be developed into Hyde Park.

The Beginnings of Cigar City

(1880–1899)

Intersection of Monroe and Lafayette streets viewed from the courthouse. In the foreground is the "Hanging Tree" reputedly used in lynchings. Monroe Street was renamed Florida Avenue and Lafayette Street is now John F. Kennedy Boulevard. (1882)

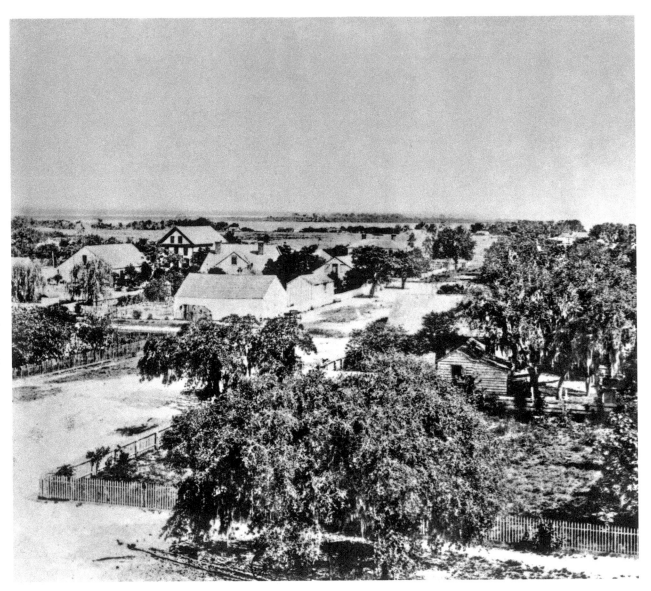

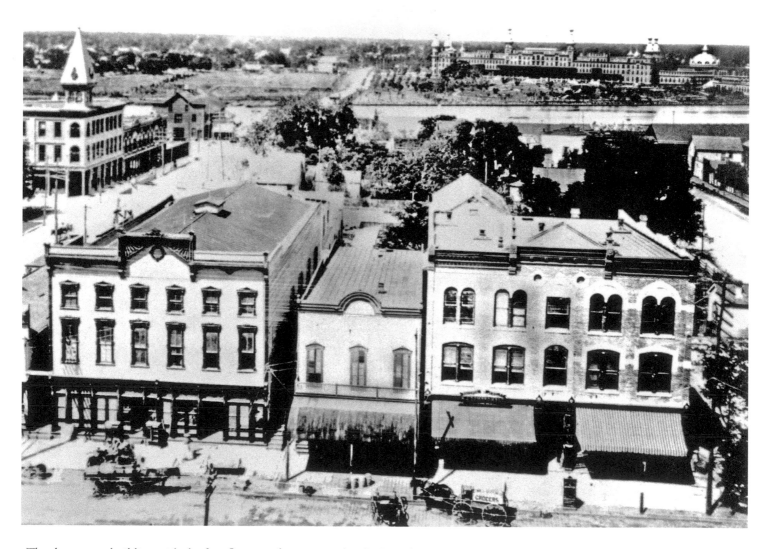

The three-story building with the first floor windows exposed is the Branch Opera House on Franklin Street, which runs left to right at the bottom of this photograph. Lafayette is the intersecting street that is visible to the left. The building with the spire on Lafayette is the hardware store of Knight and Wall. The Tampa Bay Hotel is visible near the horizon.

A view up an unpaved Franklin Street, seen from Washington Street. A trolley is on the far left of the road and horse-drawn carriages are at center and right.

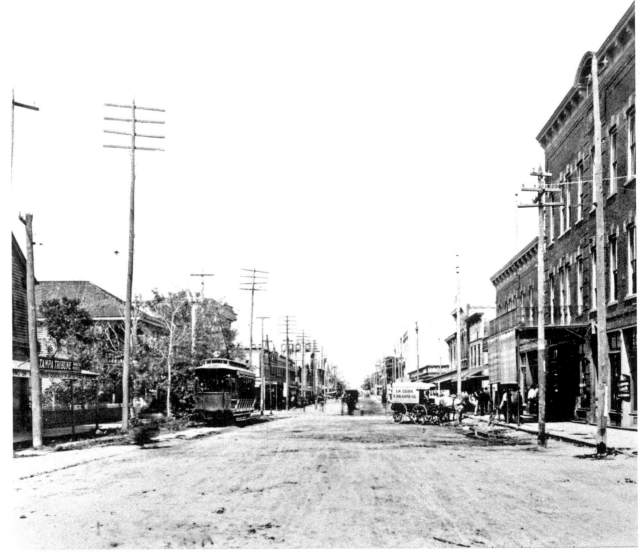

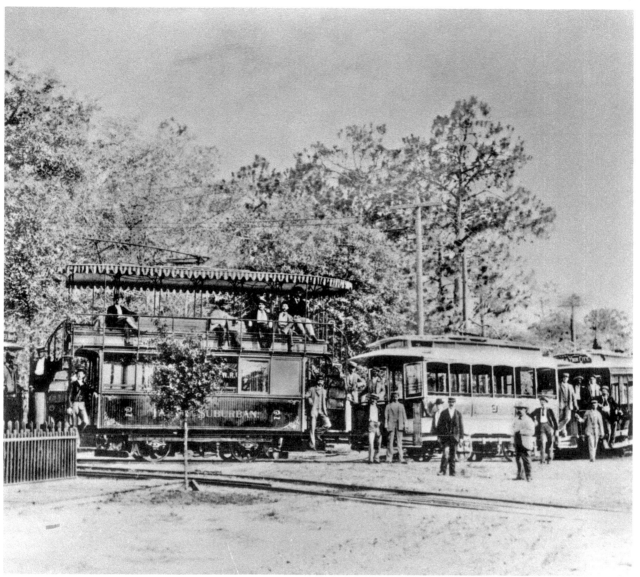

Passenger service aboard regular and double-decker streetcars of the Tampa Suburban Company. This train is on the Ballast Point route.

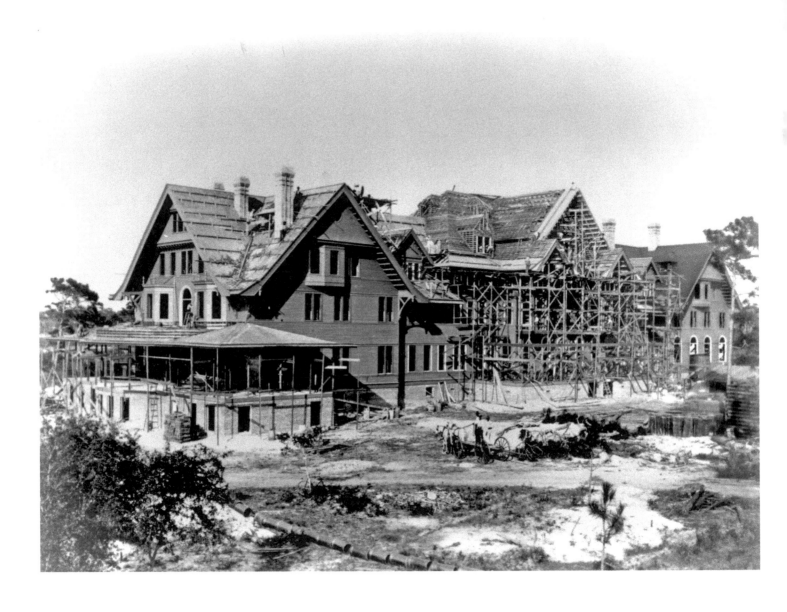

The Belleview Hotel under construction in 1896. The hotel, built by Henry B. Plant, opened in 1897 on the Clearwater Harbor in Belleair, Florida, accessible from Tampa by railroad. The hotel was purchased from the Plant family in 1920 by the Bowman-Biltmore Hotel Corporation and was renamed the Belleview-Biltmore Hotel.

Dawn of the Twentieth Century

(1900–1919)

Two couples on parade in a decorated 1903 Cadillac automobile. The parade was part of the festivities of the first Gasparilla Carnival, an annual event in which an honored local businessman assumed the role of the Spanish pirate, José Gaspar, to invade and capture the city of Tampa.

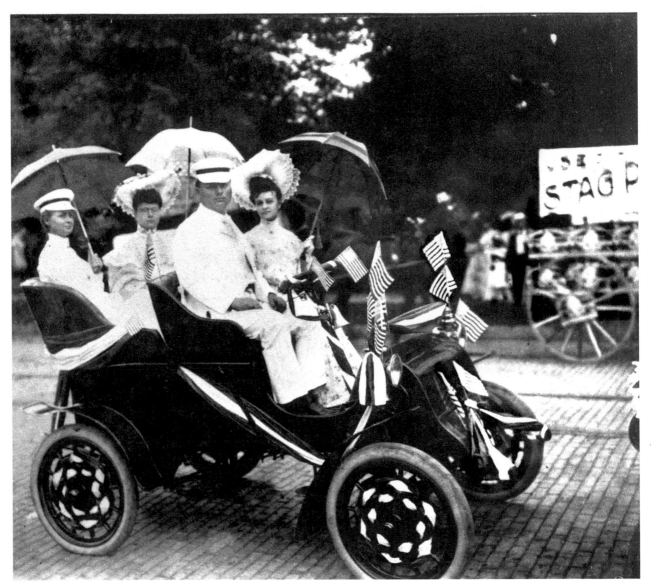

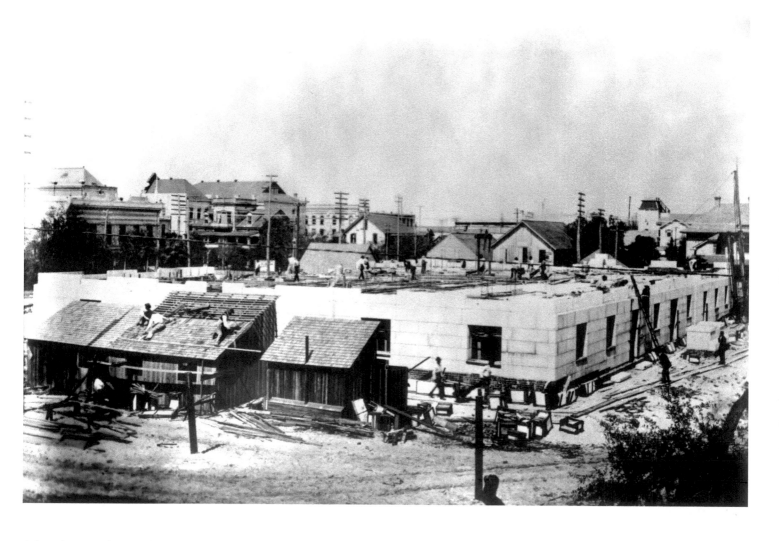

This photograph was taken in March 1903 and charted the progress of the construction of the Federal Building at Marion and Zack streets.

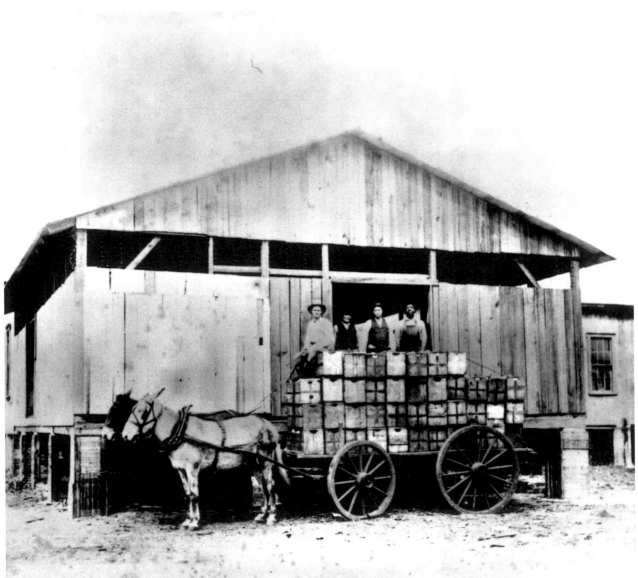

A group shot of employees of Lewis Trucking Company. Trucking in 1900 referred to a strong team of horses or donkeys and a wagon.

The First
Presbyterian
Church, located
at Florida
Avenue and
Zack Street.
This church is
in the Victorian
style with
beautiful stained
glass and high
steeple.

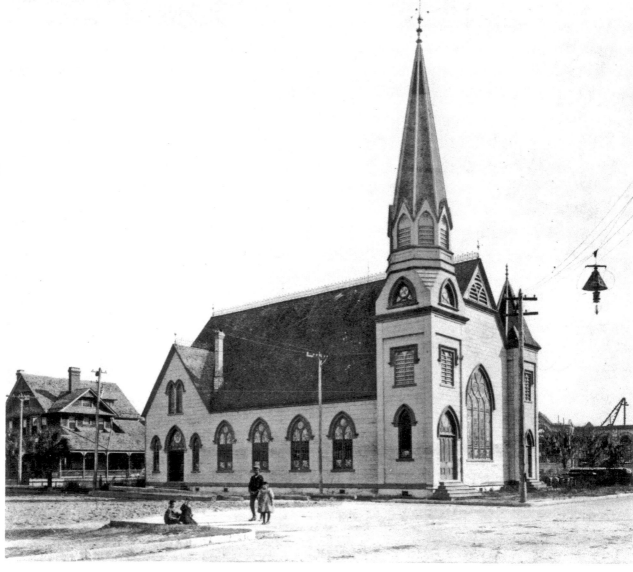

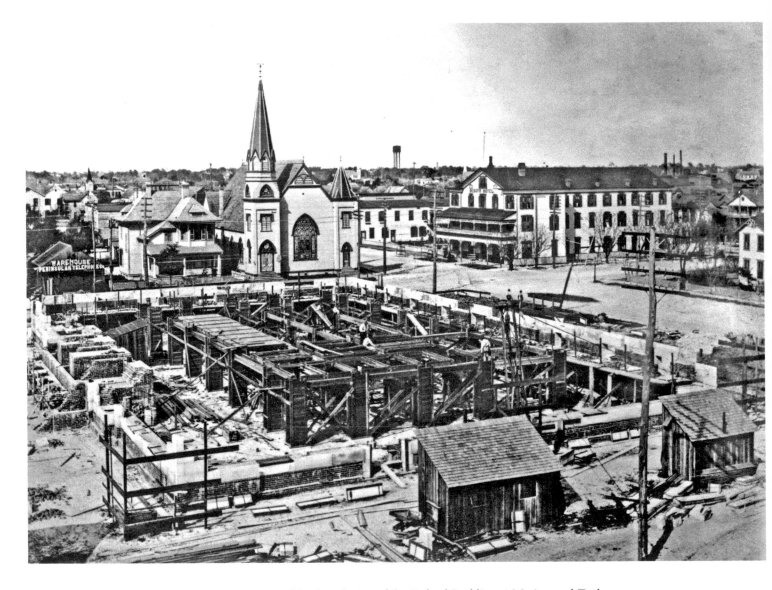

This photograph from 1903 shows construction of the foundation of the Federal Building at Marion and Zack streets. Beyond the construction site is the First Presbyterian Church. The De Soto Hotel is to the right of the church.

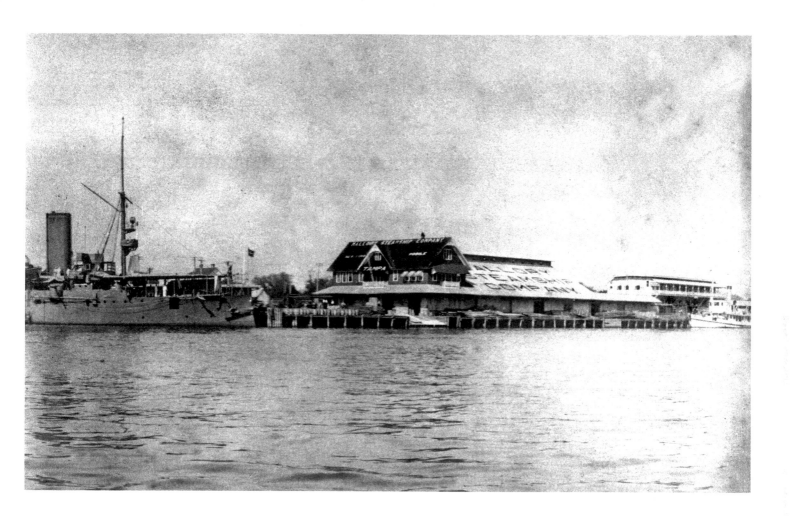

A view of the Mallory Steamship Company docks at the Port of Tampa. After channel dredging in 1908, which allowed large seagoing ships to dock in Tampa, the port became a part of the shipping circuit for Mallory and others. The routes of the Mallory line included ports of call in New York, Key West, and Mobile.

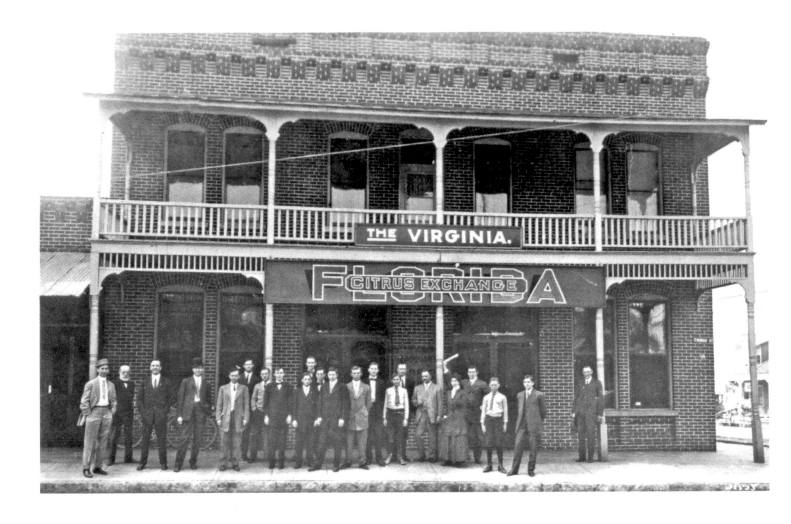

From 1910, this is the Florida Citrus Exchange Building on Twiggs Street in Tampa. The brick building has a wooden porch and wide sidewalk.

This second, sturdier version of the Lafayette Street Bridge was built in 1896. The road surface of the pictured bridge was wooden plank. The bridge also carried street rail tracks. Construction of the bridge precipitated growth west of the river. The third iteration of the bridge would be constructed between 1912 and 1913. (Circa 1910)

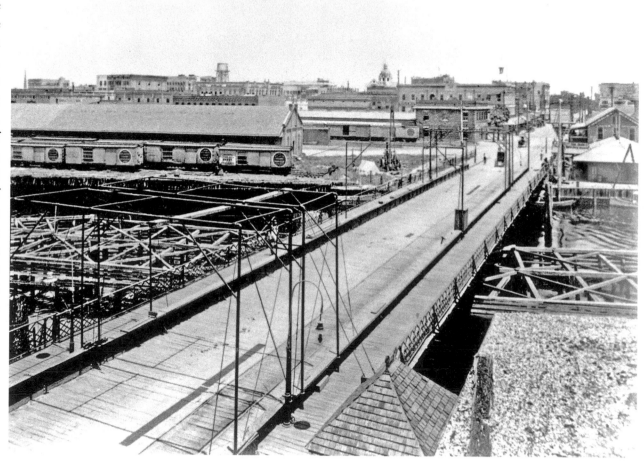

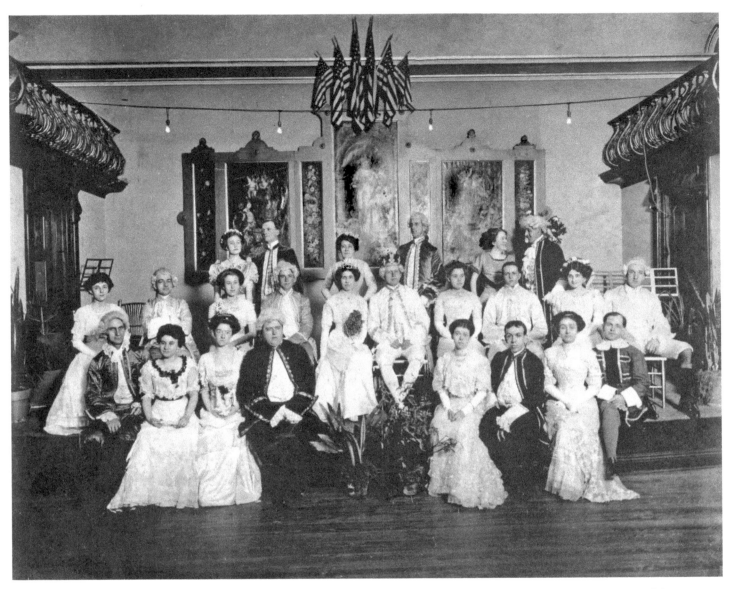

Ye Mystic Krewe of Gasparilla did not invade Tampa in the years from 1907 to 1909. The Krewe returned in 1910 as part of the Panama Canal Celebration, which marked progress on canal construction and a Congressional joint resolution proclaiming Tampa as the nearest adequate port to the canal. The Gasparilla Carnival capped the festivities. The photograph reveals the royal court with King Edward Hendry and Queen Kathleen Phillips seated in the center of the front row during the coronation ball at the Tampa Bay Hotel.

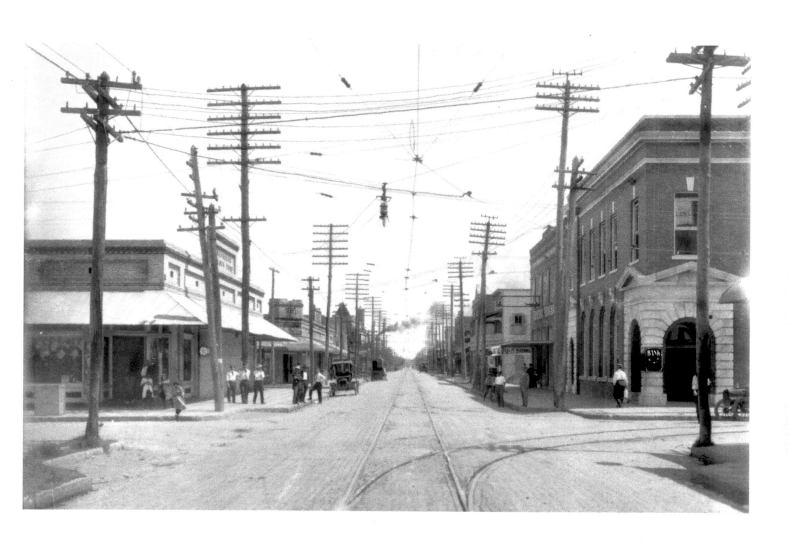

The street rail lines seen running east on Main Street and south down Howard Avenue in the City of West Tampa. West Tampa was the creation of immigrant Hugh Campbell Macfarlane. Development began in 1892. The photograph was taken in 1911.

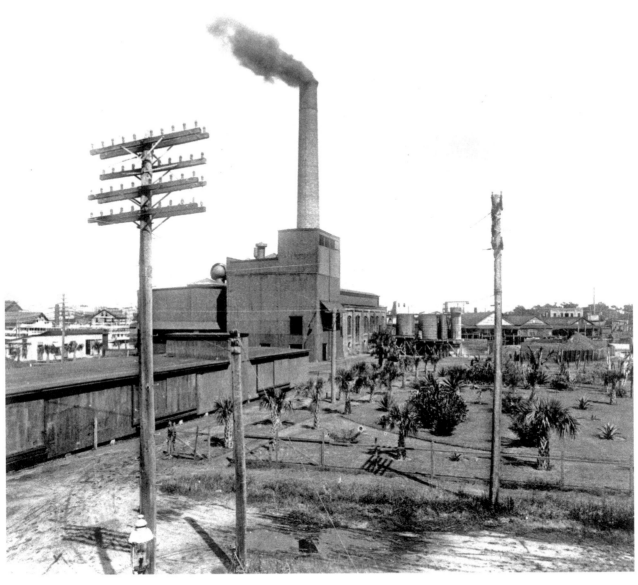

The Hyde Park
power plant of
Tampa Electric
Company as
seen from
Parker Street.
Beyond the
grounds of the
plant and
across the river,
buildings of
the Port of
Tampa are
visible.

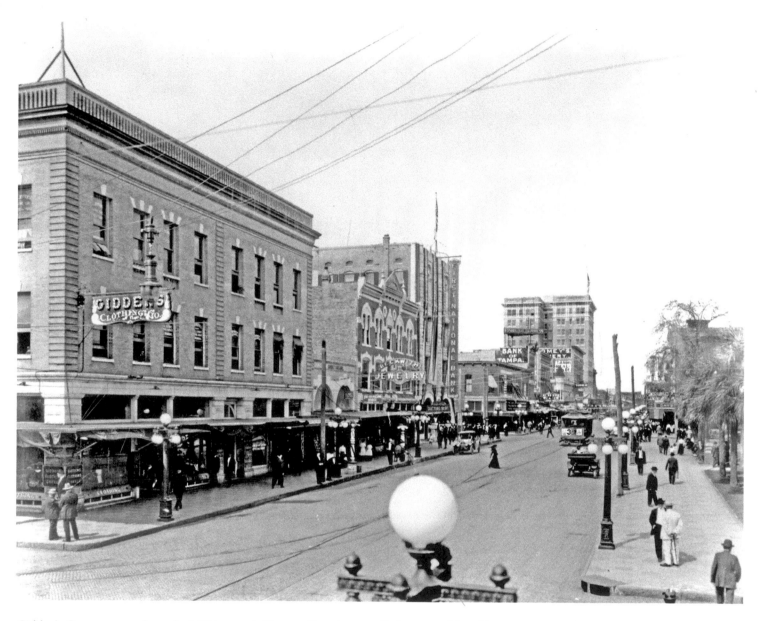

Gidden's Corner, across from the Hillsborough County Courthouse at Lafayette and Franklin streets. The tall building toward the end of Franklin is the Citizen's Bank. (1912)

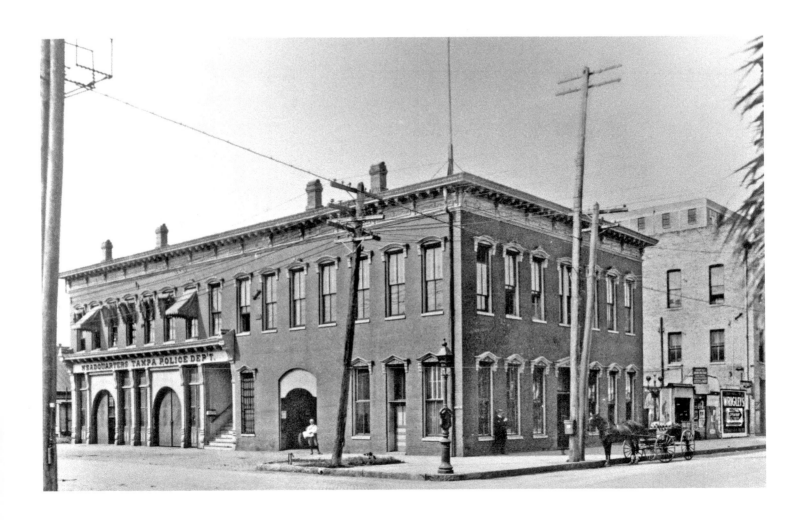

Before the beautiful City Hall building which features the clock tower, this 1914 photograph captures the two-story brick building which formerly housed both City Hall and police headquarters.

The Children's Home was created as a safe haven for children orphaned by industrial and farming accidents or disease. Photographed here is a group of young residents in front of the living facility on Florida Avenue between 26th Avenue and Emily Street.

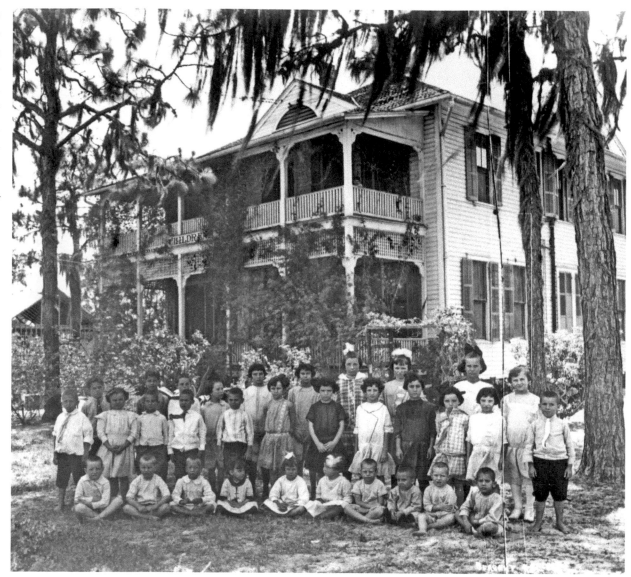

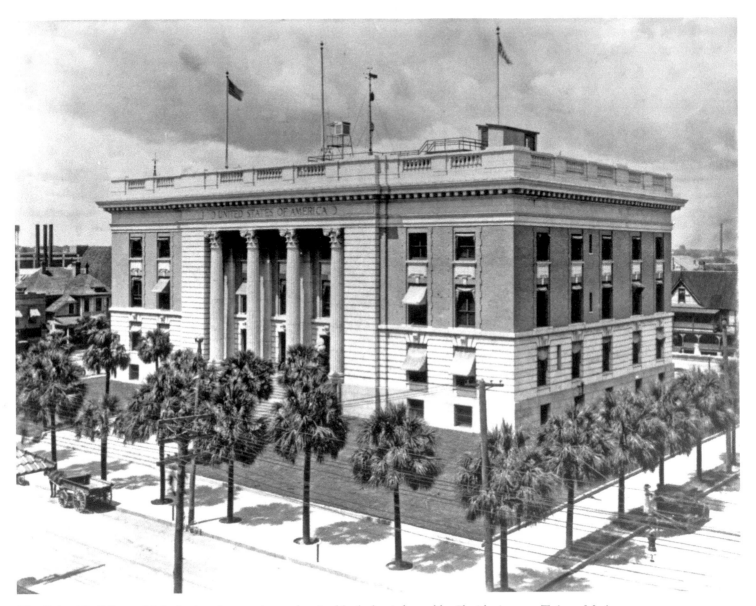

The Federal Building, with its Ionic columns, sits on the city block that is bound by Florida Avenue, Twiggs, Marion, and Zack streets. The building, seen here in 1915, was ringed in palm trees.

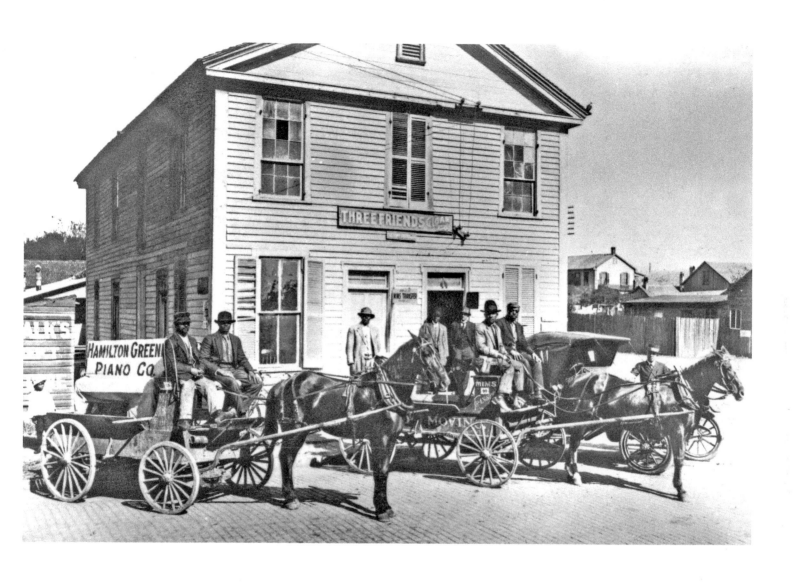

In 1915, there were more than 100 cigar manufacturers in Hillsborough County. Pictured here are employees of Mims Transfer Company in front of the wood-frame factory of Three Friends Cigar Company on East Scott Street in Tampa.

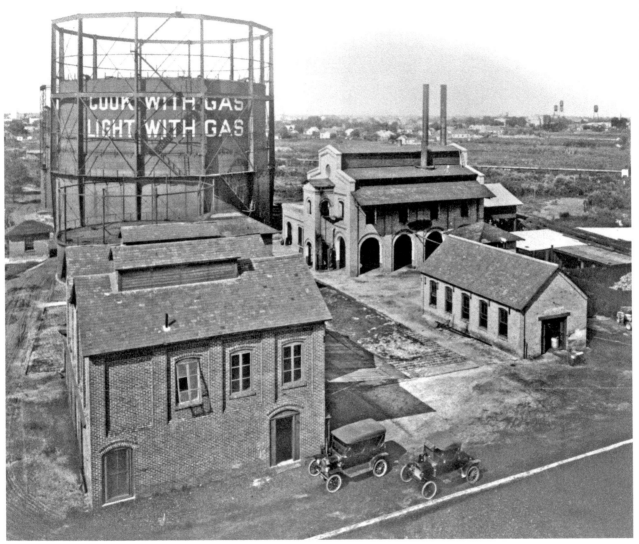

Though electric power had come to Tampa as early as the 1890s, gas power was a very reliable option for light and heat. The Tampa Gas Company was near Ybor Channel on Twelfth Street between First and Second avenues in Ybor City. First Avenue was renamed Adamo Drive in honor of Dr Frank Adamo, a Tampa native who achieved worldwide acclaim for his treatment of gangrene.

The Elk Club, Lodge 708, was located at the corner of Florida Avenue and Madison Street, was built of red brick and marble in 1913. This photograph was taken two years after its completion.

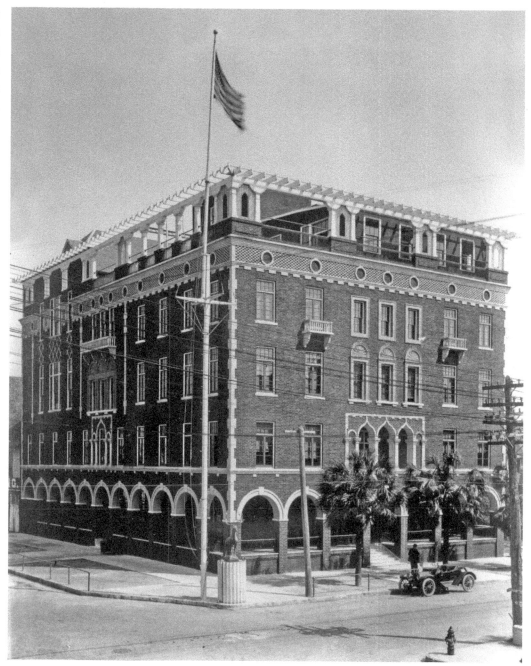

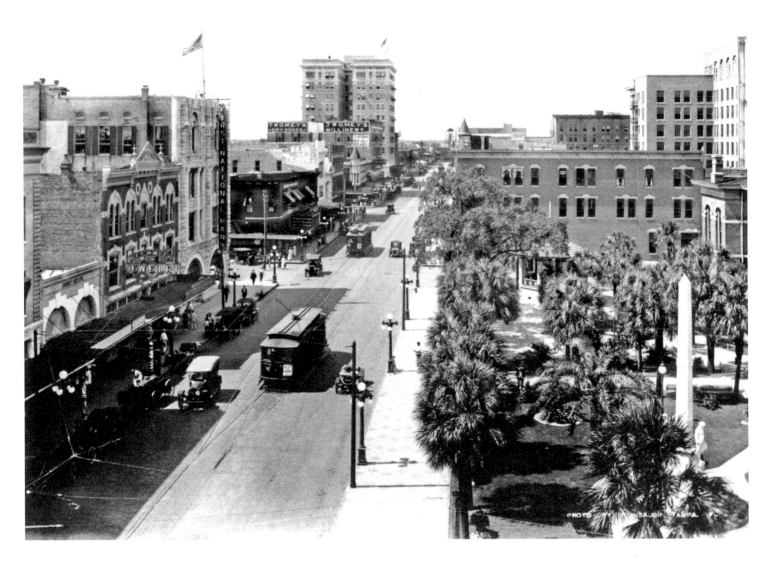

In 1915, Franklin Street was the hub of commerce. The Hillsborough County Courthouse with the Civil War Memorial is in the lower right of the frame. The First National Bank is across the street, flying the Stars and Stripes. The tall building farther north on Franklin is the Citizen's Bank.

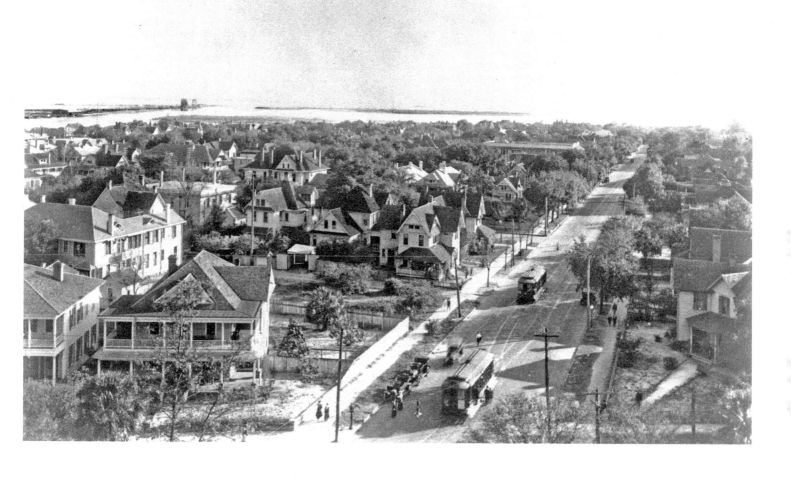

Streetcars and pedestrian traffic along Hyde Park Avenue. This view, from the vantage point of the Tampa Bay Hotel, encompasses Hillsborough Bay and streets of fine residences. (1913)

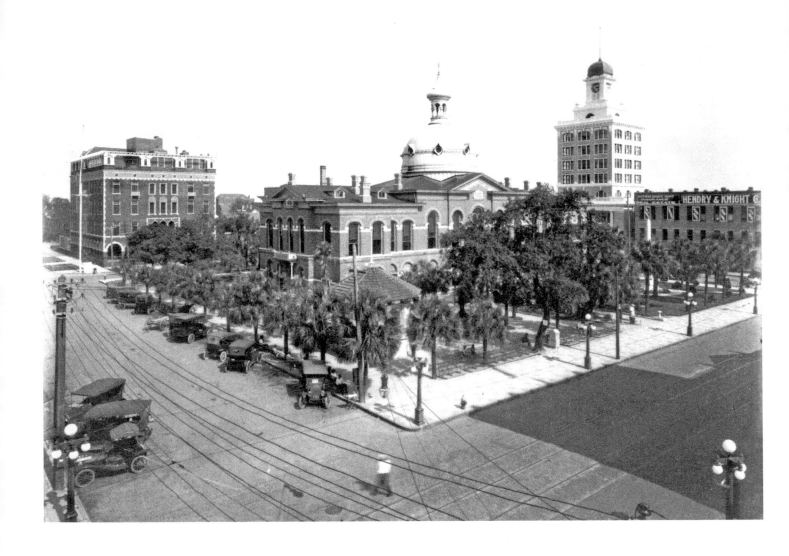

The original Hillsborough County Courthouse with its dome and minaret are seen here in September 1915. The courthouse faced Franklin Street. Shown here is the intersection at Madison Street. Beyond and to the right of the courthouse is Tampa City Hall with its clock tower.

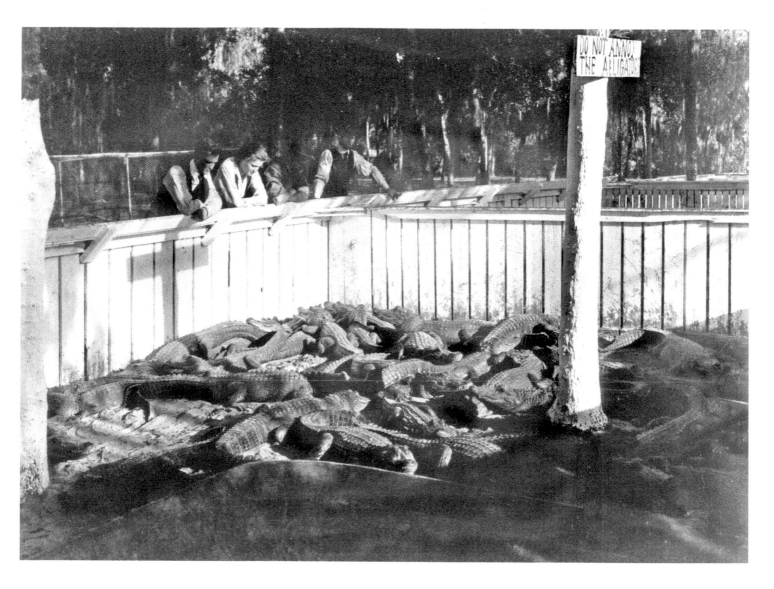

Sulphur Springs, north of early Tampa, was first developed and opened to the public by Dr. J. H. Mills in 1908 as a public swimming area and amusement pavilion. It was connected to Tampa via a trolley line, built by Tampa and Sulphur Springs Traction Company. Here, a small group views captive alligators.

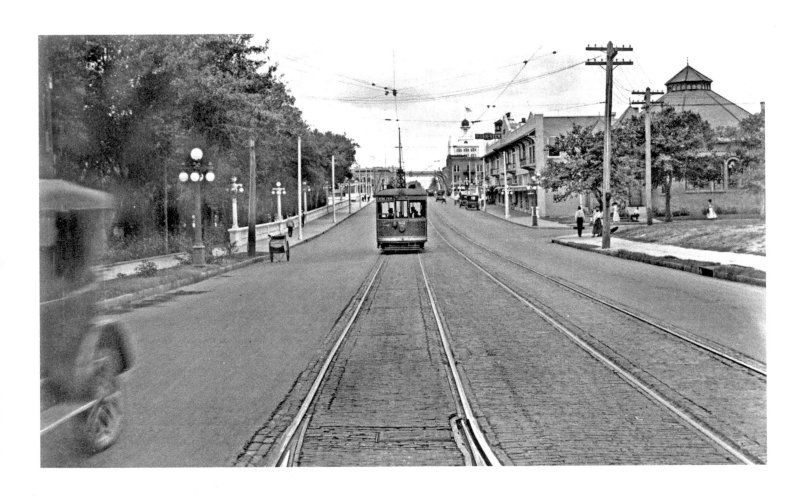

An electric streetcar plies Lafayette Street, seen from the intersection at Hyde Park Avenue, looking eastward toward downtown.

At the Port of Tampa in 1917, stevedores unload barrels of asphalt from the wooden-hulled, masted freighter *Hope*.

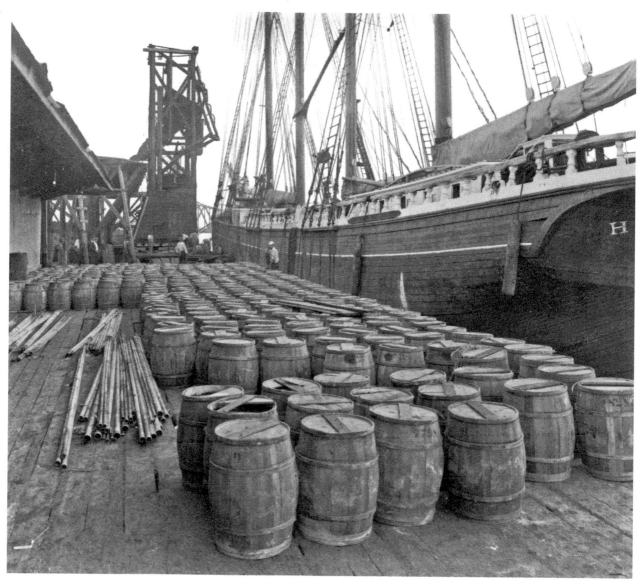

The intersection of Bay Street and Hyde Park Avenue in 1916. This view looks southwest across Hillsborough Bay with homes along Bayshore Boulevard in the distance.

The neat, upscale neighborhood of Hyde Park. The subdivision was created by O. H. Platt of Hyde Park, Illinois, in February 1886.

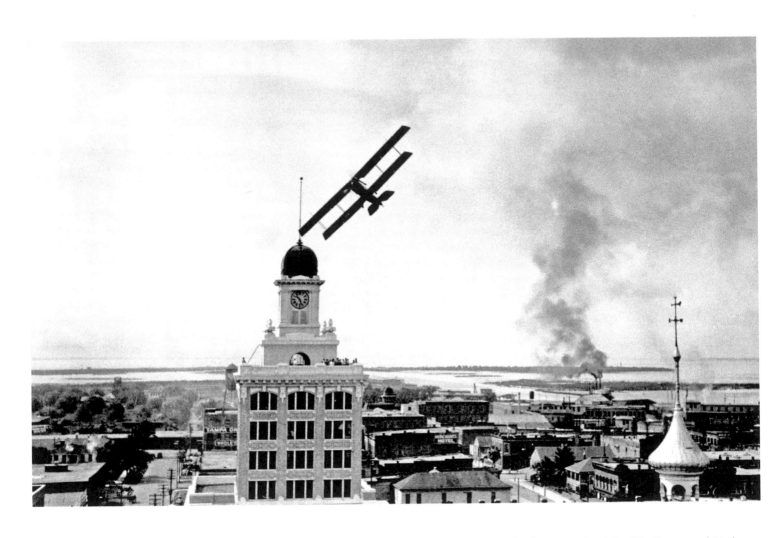

A biplane flying over City Hall. The minaret of the Hillsborough County Courthouse is in the frame on the right. Big Grassy and Little Grassy Key, later known as Davis Islands, are visible in the distance.

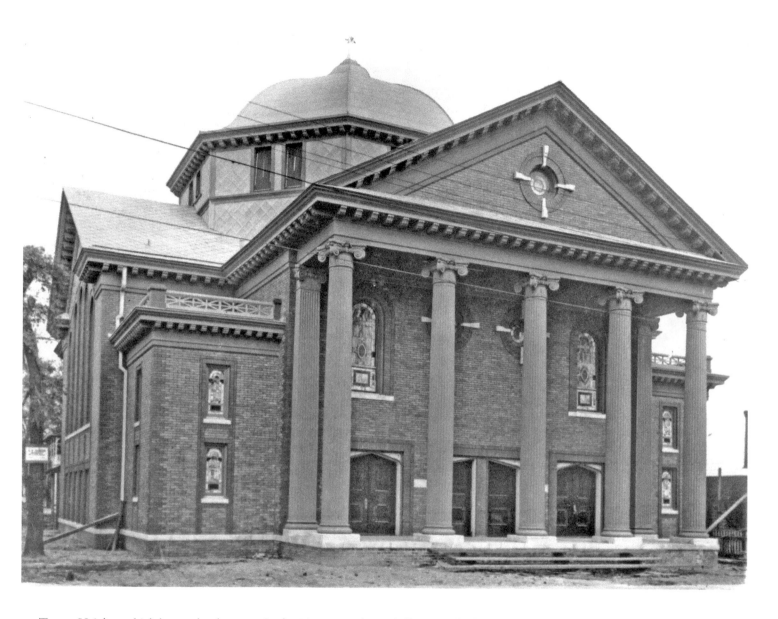

Tampa Heights, which began development in the 1890s, was the city's first completely residential suburb. The Tampa Heights Methodist Church, at 503 East Ross Avenue, was built in 1910 and had a congregation as large as 1,600.

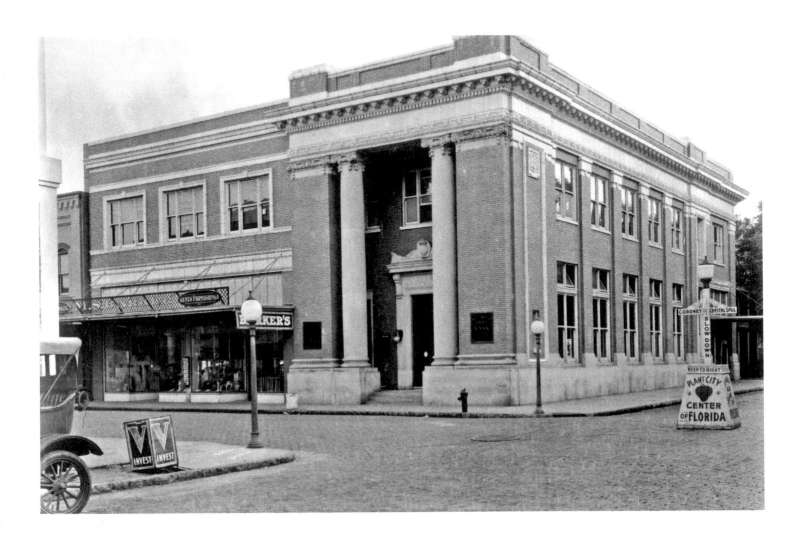

This is the Hillsboro State Bank on North Collins Street in Plant City, which lies 24 miles east of Tampa. Plant City, a predominantly agricultural community, was incorporated in 1885. The city was named after Henry B. Plant.

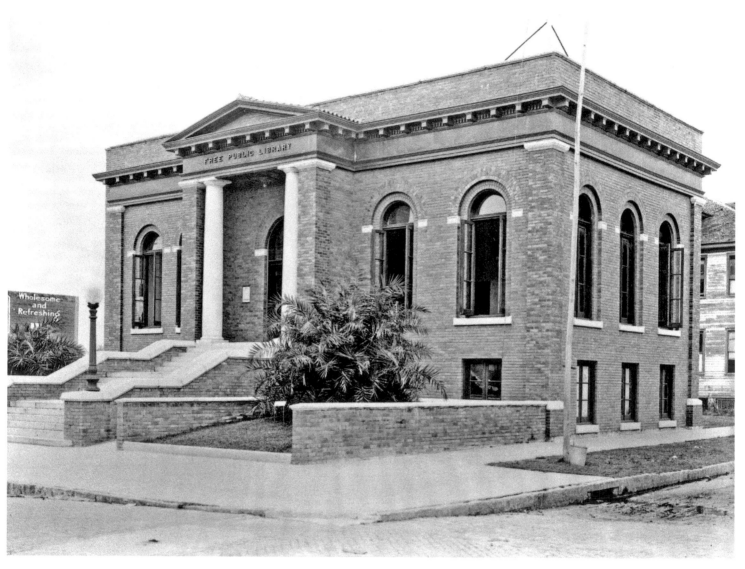

The West Tampa Public Library on North Howard Avenue was the second free library in the county. The building is pictured here around the time of its opening in 1918.

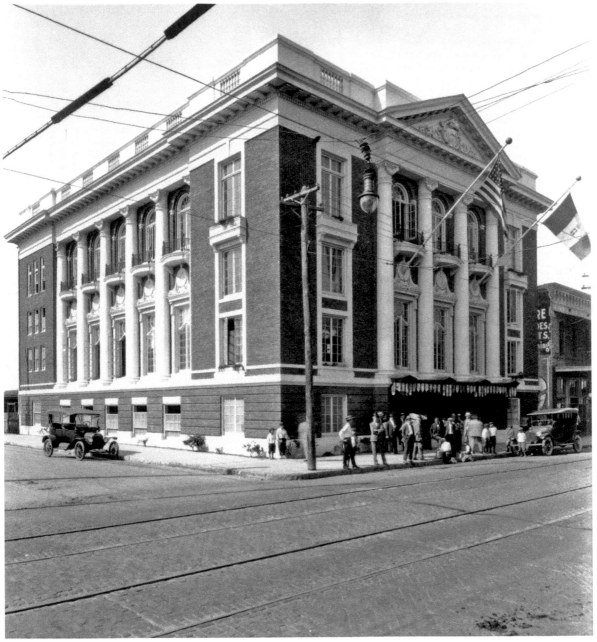

L'Unione Italiana is a social and benefit club founded in 1894. Members were eligible for shared medical expenses and death benefits. The original club was destroyed by fire in 1915. This new building, erected in 1917, features Classical and Mediterranean architectural elements.

Centro Asturiano de Tampa, designed in Neo-classical Revival and Beaux-Arts styles, is pictured here around 1920. The building was located on North Nebraska Avenue and held facilities for amusement and entertainment. Members of the social club enjoyed health care benefits and a death benefit.

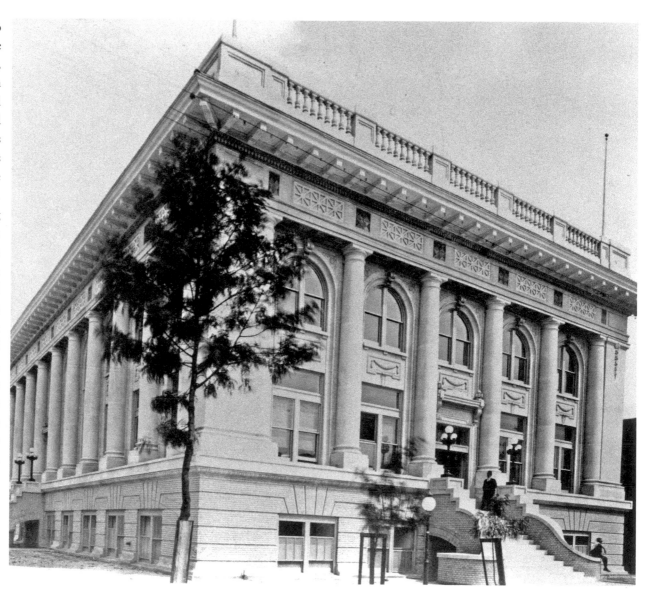

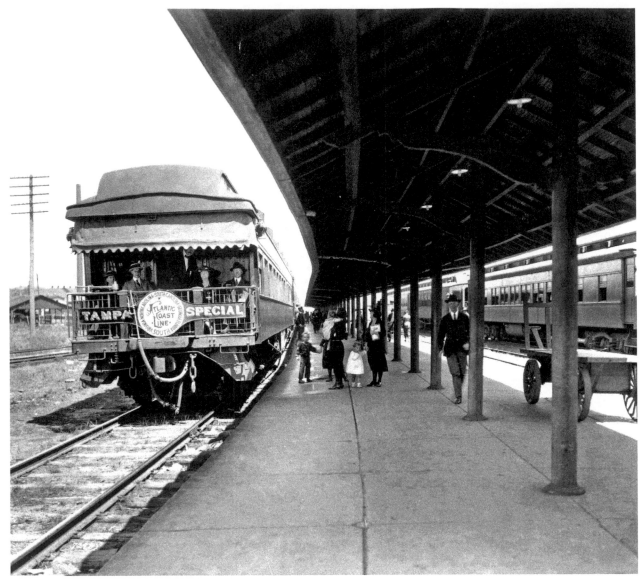

The Tampa Special rolls into Tampa Union Station at Nebraska Avenue and Twiggs Street. This passenger train was a part of the Atlantic Coast Line Railroad.

The Era Between the Wars

(1920–1939)

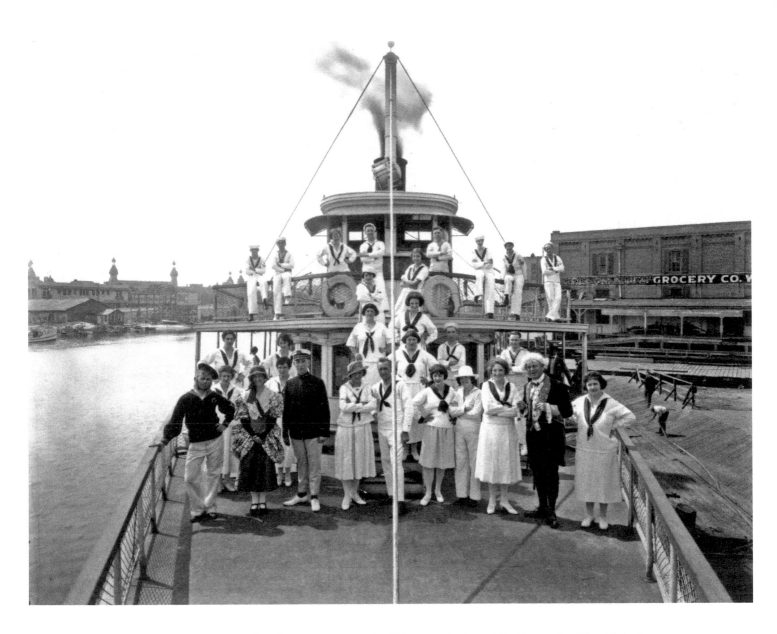

The cast from the operetta *HMS Pinafore* aboard a steamboat on the Hillsborough River. The Tampa Bay Hotel is in the background to the left.

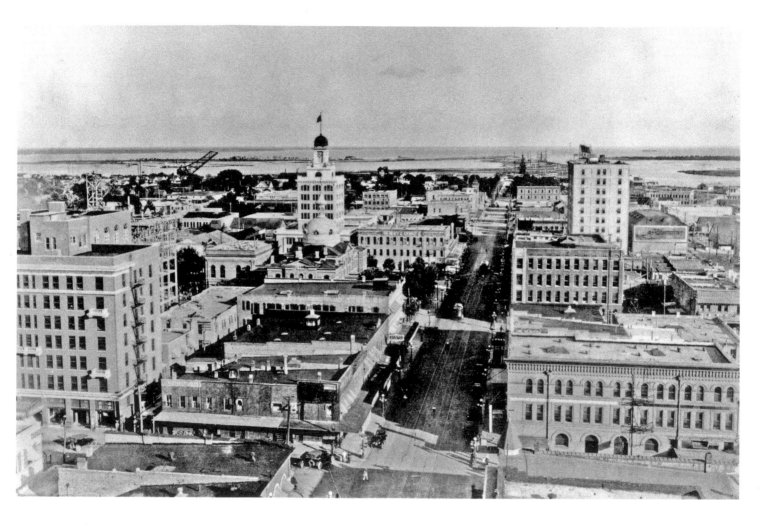

This is a 1920 view south on Franklin Street toward Garrison Channel and Seddon Island. The clock tower and cupola of City Hall stands out boldly on the skyline. The photograph was taken from the roof of the Citizen's Bank Building.

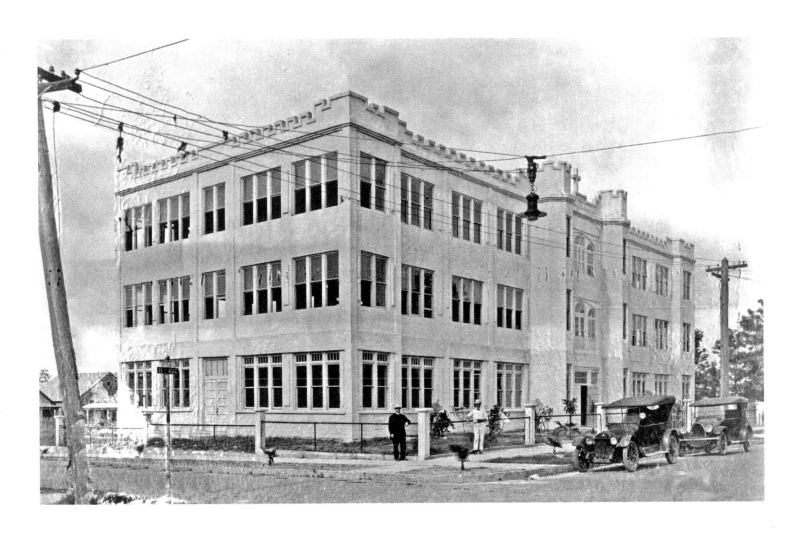

St. Joseph's Convent located at Eleventh Avenue and Eighteen Street in Ybor City. Associated with St. Joseph's Hospital, the nuns of the convent worked the hospital wards, providing care and comfort.

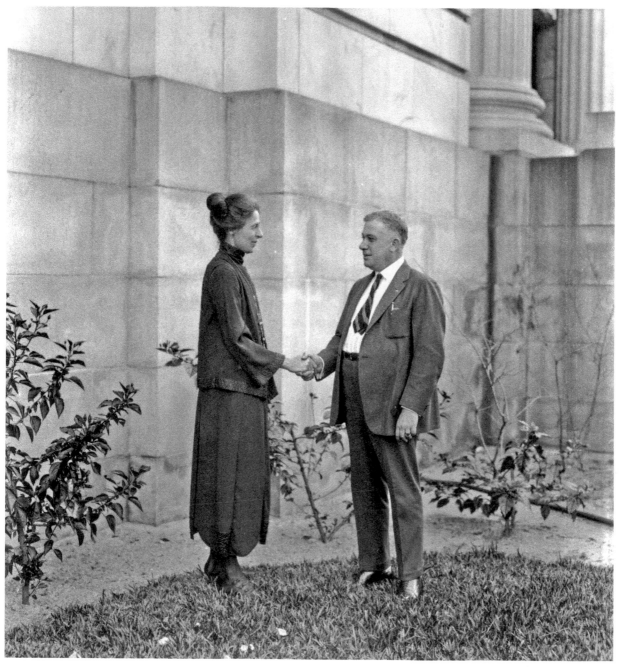

Postmistress Elizabeth Barnard with Edwin Lambright, the Assistant Editor of the *Tampa Morning Tribune,* on the grounds of the Federal Building, photographed in January 1923.

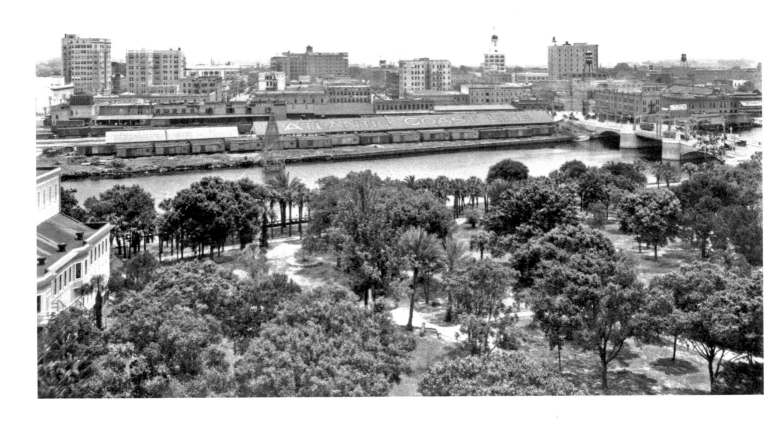

Shot in 1921, this is a view from the Tampa Bay Hotel looking eaast across the Hillsborough River at the skyline. The structure on the river is a bat tower. Over the years Tampa had had bouts with malaria and yellow fever, both mosquito-borne diseases. Bat towers were built along the river because of bats' natural appetite for mosquitoes.

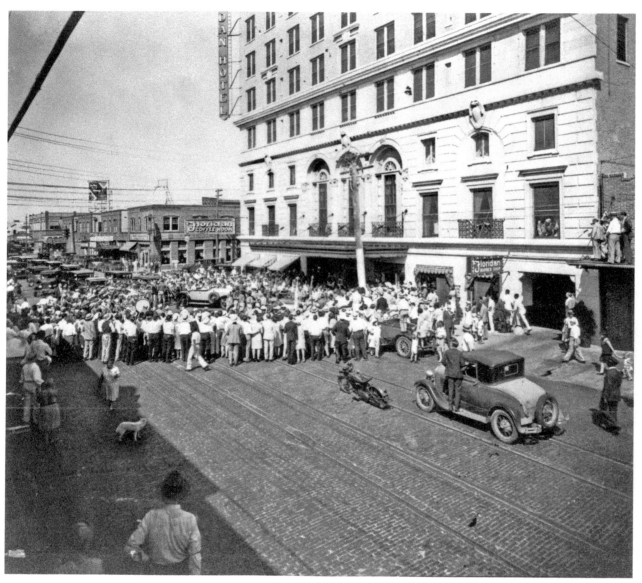

A crowd outside Floridan Hotel has the traffic on Cass Street drawn to a stop.

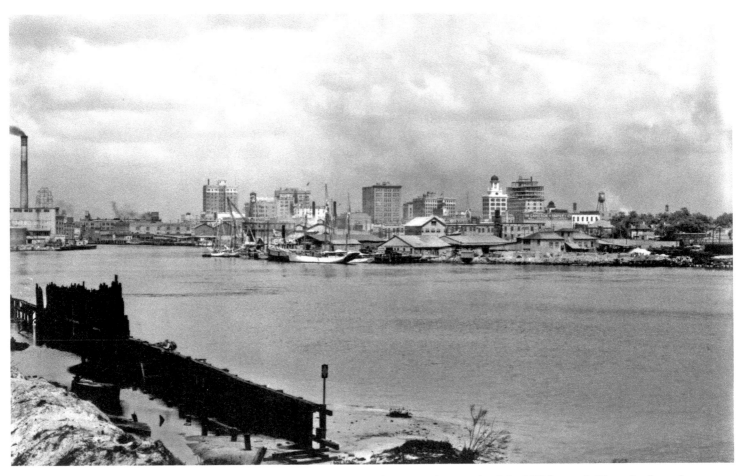

Construction of the seawall in 1925 on the northern tip of Davis Islands. Across the mouth of the Hillsborough River the domed tower of City Hall is visible.

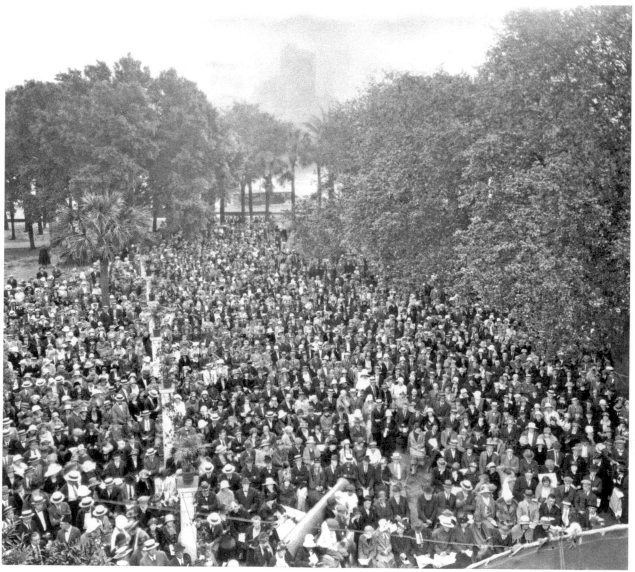

Sunrise service on Easter morning 1925. Worshipers are assembled in Plant Park adjacent the Tampa Bay Hotel. The skyline of Tampa is barely visible through an early morning fog over the Hillsborough River.

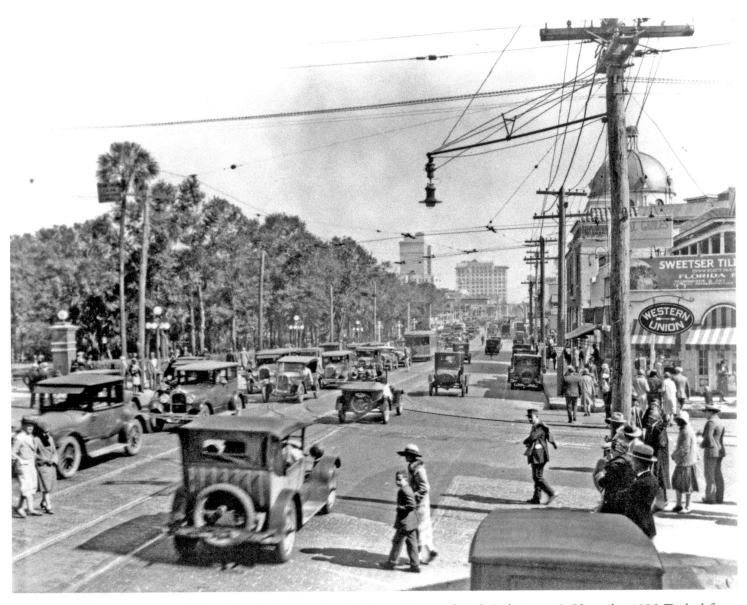

Pedestrian and automobile traffic at the intersection of Lafayette Street and Hyde Park Avenue in November 1926. To the left are the trees on the grounds of the Tampa Bay Hotel. The dome seen on the right belongs to the First Baptist Church.

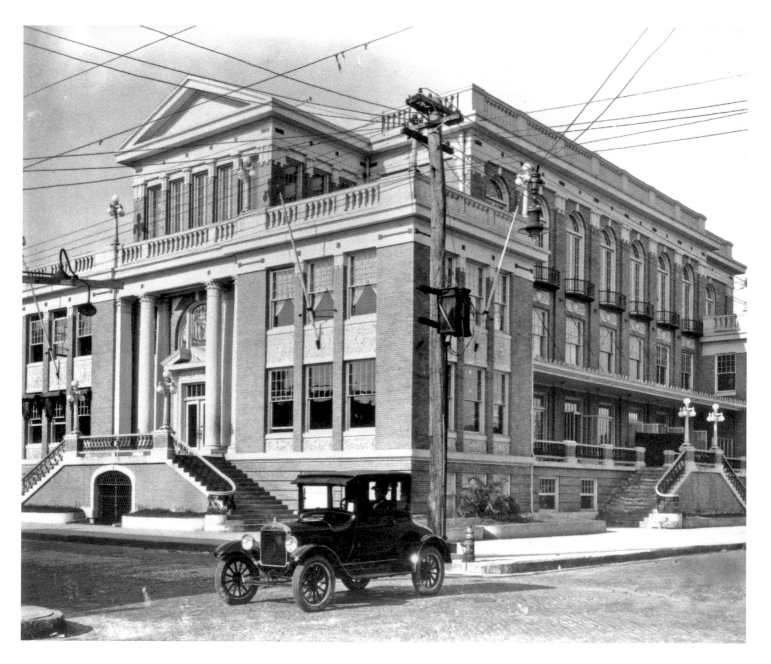

El Circulo Cubano de Tampa (the Cuban Club) as it appeared in 1926. This was a brick building with Neoclassical accents located on the Avenida Republica de Cuba near Tenth Avenue in Ybor City.

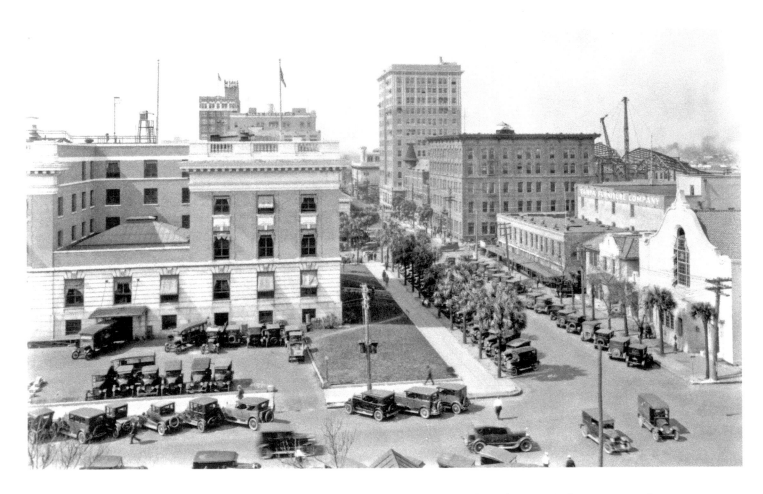

Rear view of the Federal Building. Marion Street is in the foreground, intersecting with Zack Street. (February 25 1926),

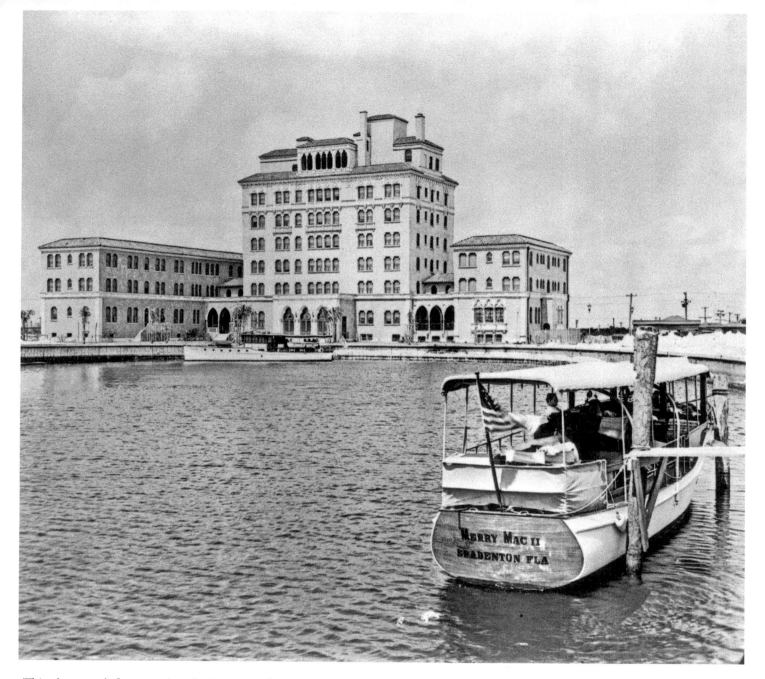

This photograph from 1926 marked the second year of development of Davis Islands. As a result, the Mirasol Hotel seems to stand alone. The Mirasol is keenly positioned on Davis Boulevard, the main road winding through the islands, and on Hillsborough Bay, making the hotel accessible by boat. The hailing port for the wooden vessel in the foreground is Bradenton, Florida, another historic and developing port city on the Gulf Coast.

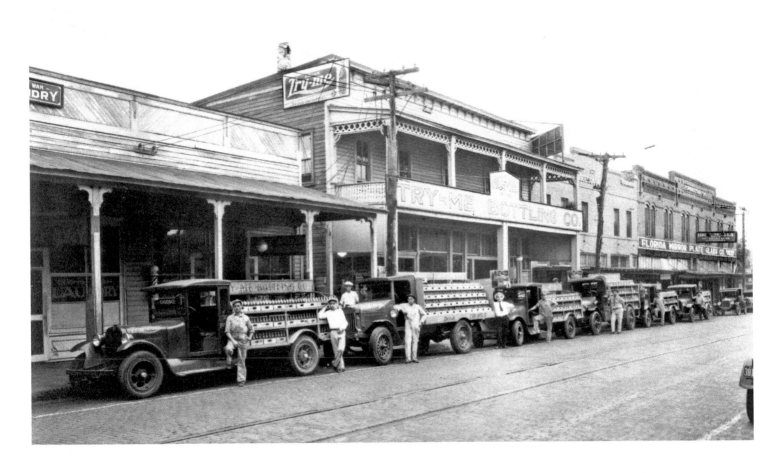

Try-Me Bottling Company on Seventh Avenue in Ybor City. Try-Me soda was produced and distributed in many southern cities.

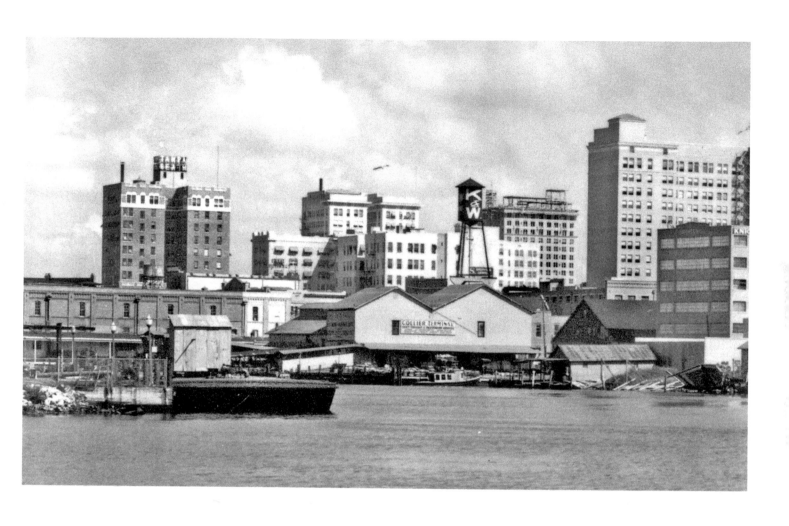

This is a 1926 view of the Tampa skyline from the foot of Cardy Street, the lower boundary of Tony Jannus Park, looking northeast across the Hillsborough River. City Hall is quite recognizable at the far-right side of the image.

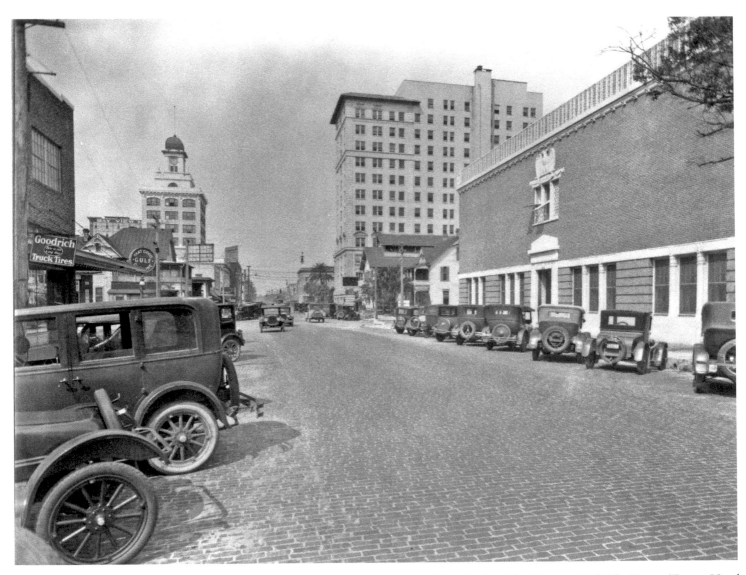

Lafayette Street near Morgan in 1926. To the right is a view of the facade of the Masonic Hall. The Tampa Terrace Hotel rises at center. City Hall is to the left, across the street from the hotel.

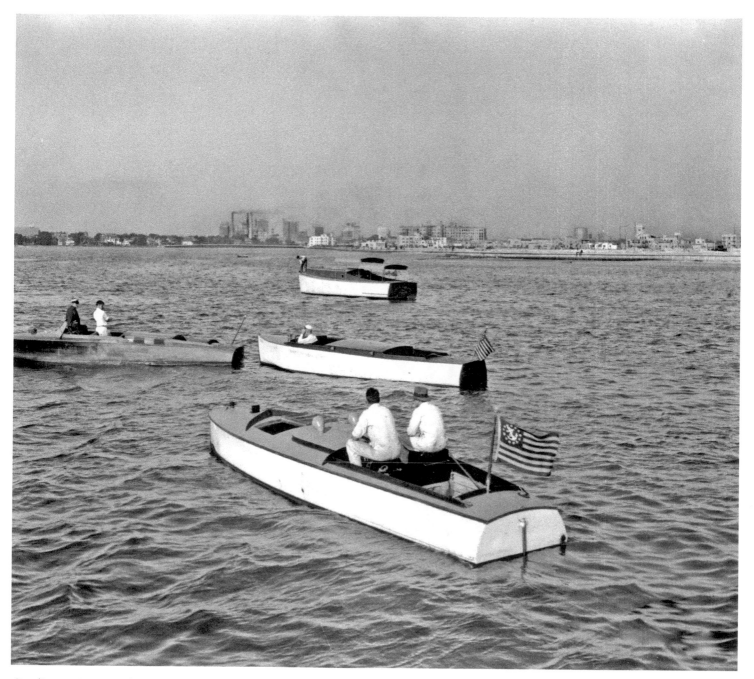

Gasoline engine powerboats on Hillsborough Bay. Bayshore Boulevard and Davis Islands are in the background. (1926)

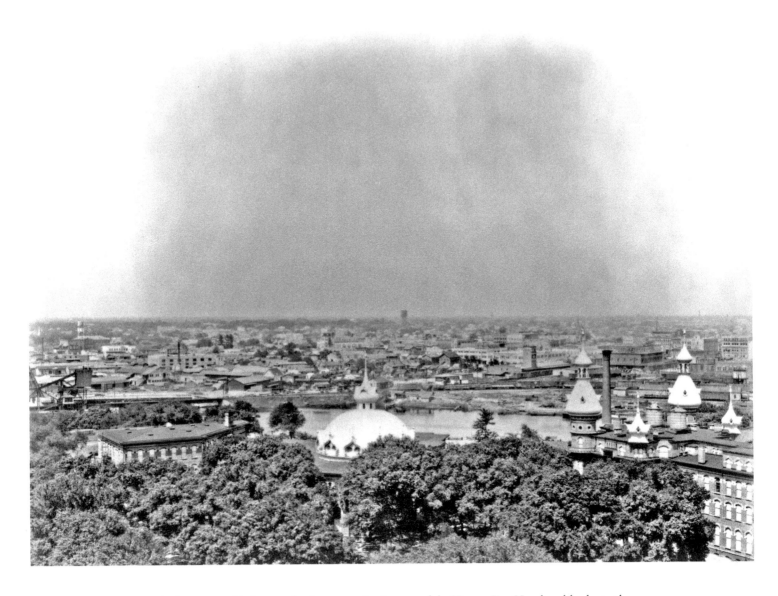

This bird's-eye view reveals the tree-studded grounds, domes, and minarets of the Tampa Bay Hotel and looks to the northeast, across the river and the northern edge of the city. At this time the hotel belonged to the City of Tampa but had not been in use for years.

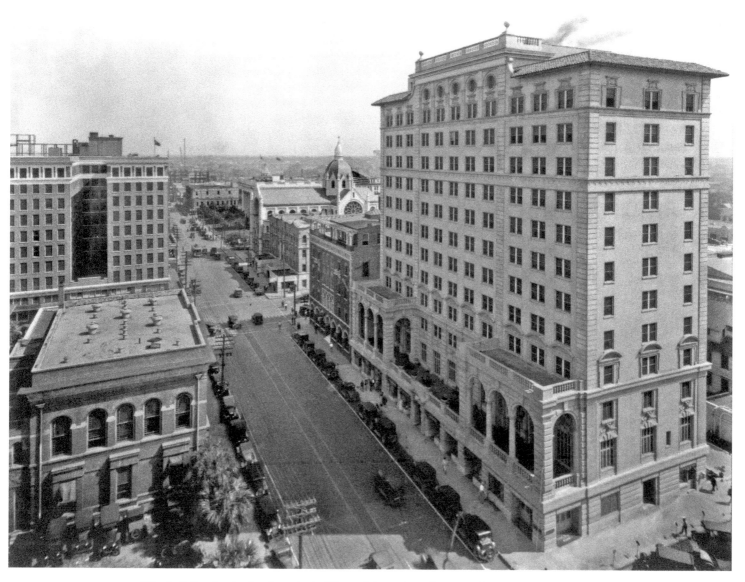

The building in the forefront is the Tampa Terrace Hotel captured here in 1926. Farther down Florida Avenue the dome of Sacred Heart Catholic Church is visible.

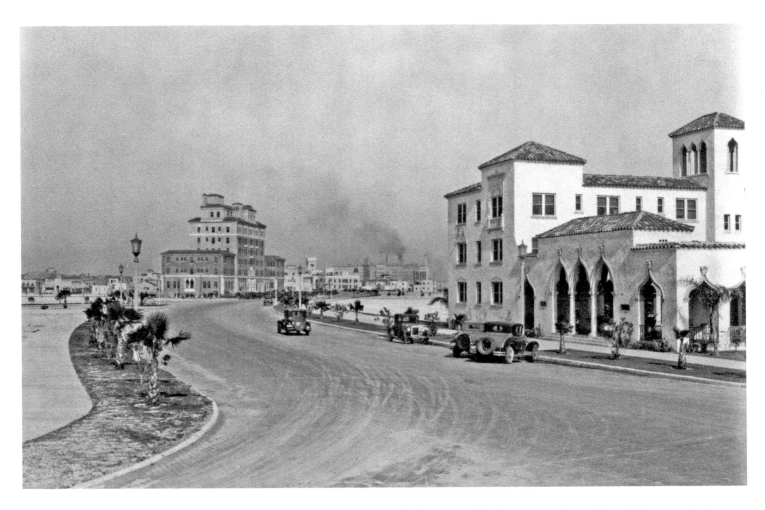

The Palmerin Hotel (right) and Mirasol Hotel (left) were built in 1925, the first year of development on Davis Islands. The grand real estate project used dredging to join and fill in two scrub-covered, marshy keys in Hillsborough Bay, just south of downtown. The following year construction would begin on the Tampa Municipal Hospital on the northern tip of the Islands.

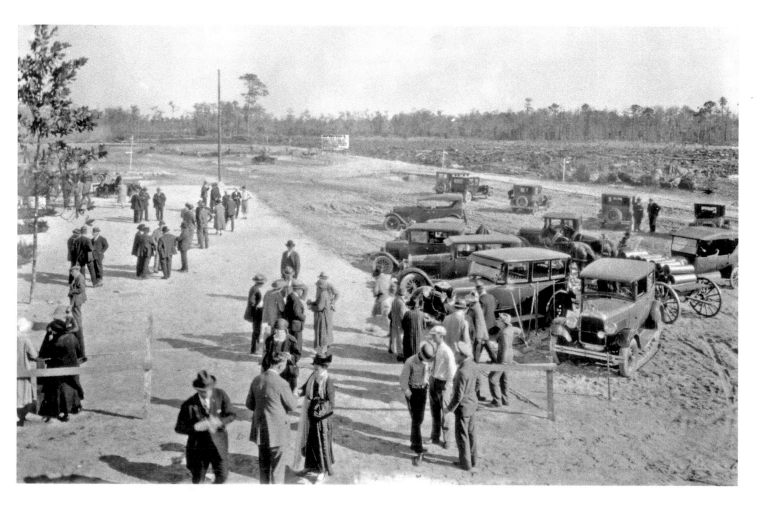

In the mid-1920s, Florida was in the midst of a real estate boom. Not only was Tampa growing rapidly, nearby communities also benefited from the growth. Here, prospective buyers from the Florida West Coast Development Corporation examine building sites at Homosassa Springs in Citrus County.

Hyde Park Motor Company, which sold Chrysler automobiles, was located at 1704 Grand Central Avenue (later renamed John F. Kennedy Boulevard).

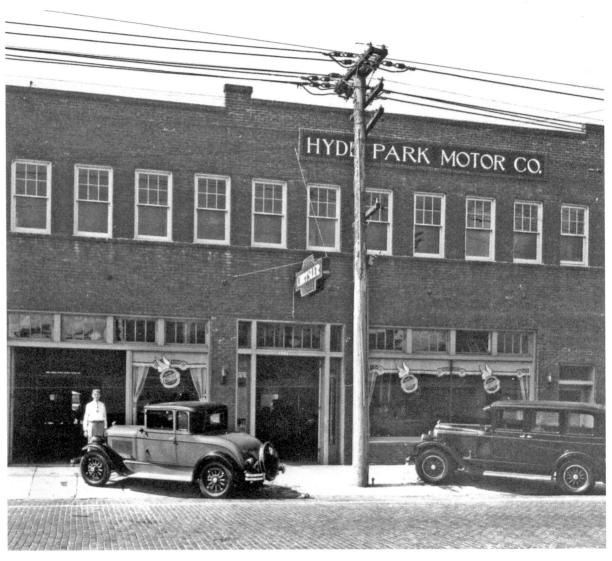

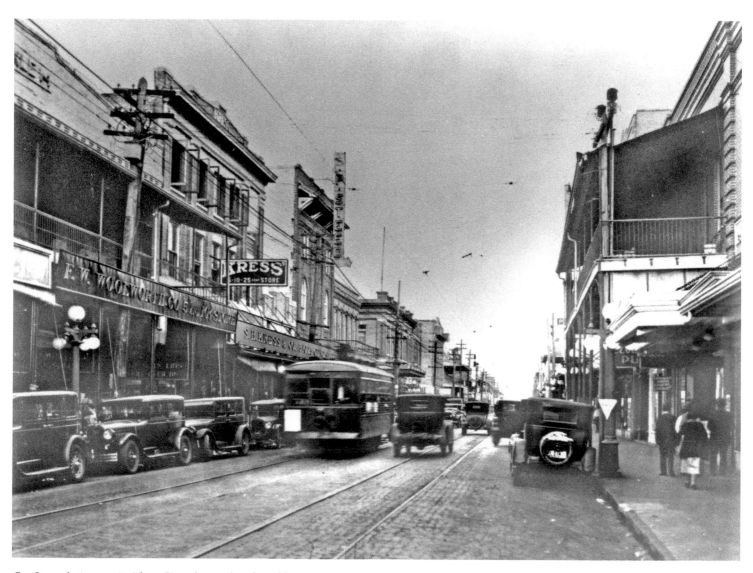

On Seventh Avenue in Ybor City, the road is shared by automobiles and streetcars. S. H. Kress and W. F. Woolworth are among the stores on Ybor City's commercial avenue.

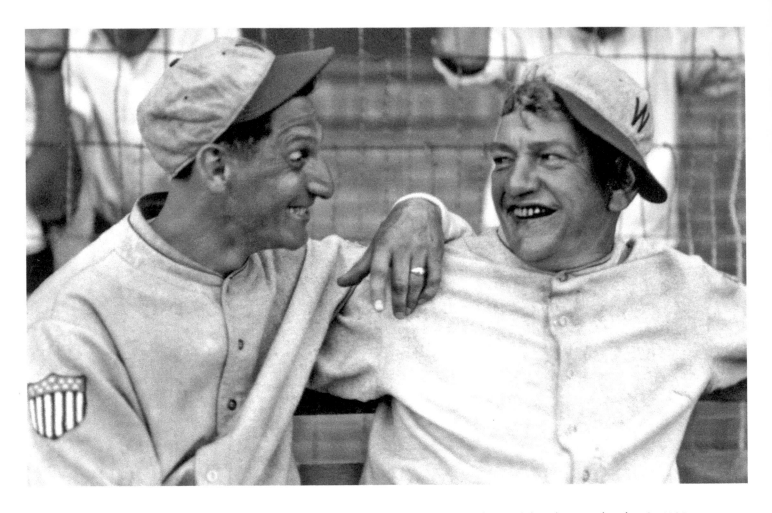

The Washington Nationals baseball team held spring training in Tampa from 1920 until 1929. This photograph, taken in 1928, is reported to be of Al Bool and Nick Cullop after a good-natured boxing match. Neither appears to be worse for wear.

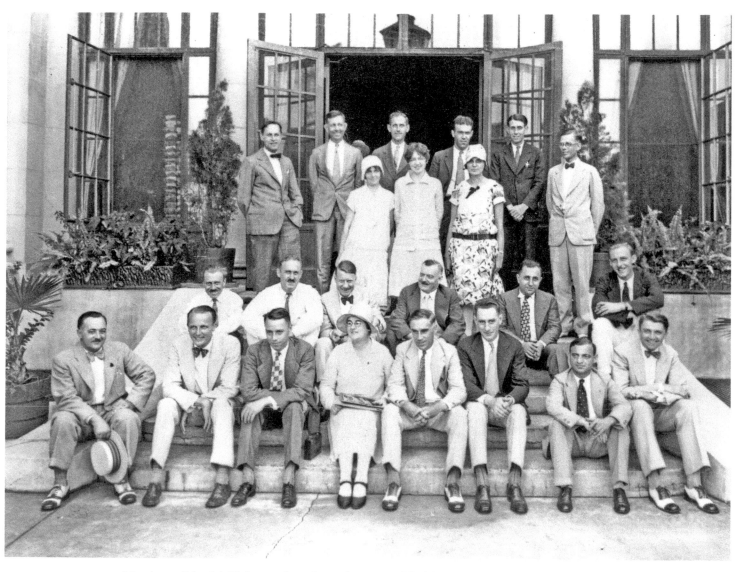

Members of the Ad Club seated on the garden steps of the Tampa Terrace Hotel, on the southwest corner of Lafayette Street and Florida Avenue. (1928)

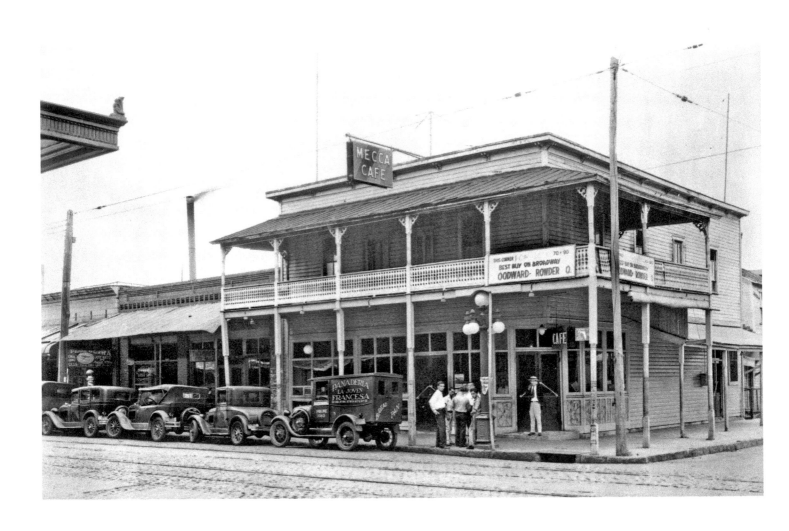

The Mecca Cafe on Seventh Avenue in Ybor City, seen here about a month before the stock market crash in October 1929, an economic event that would lead to dramatic changes for this company town that had been so important in the growth and development of Tampa.

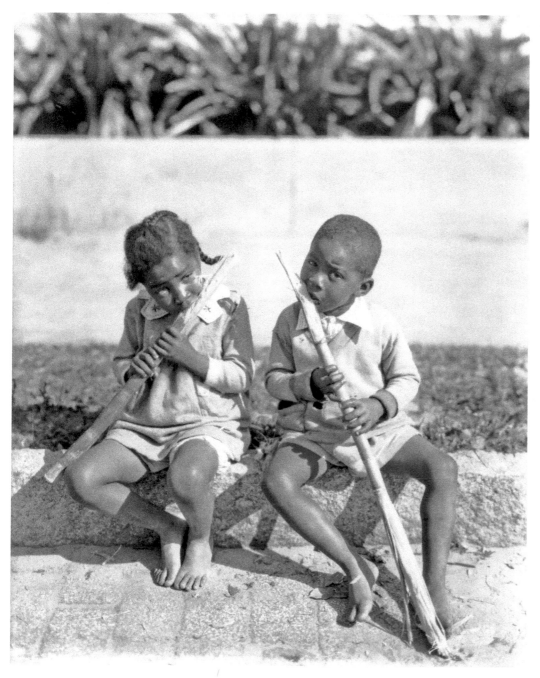

A girl and boy seated on a granite curb are enjoying sugar cane. This photograph was taken in 1931.

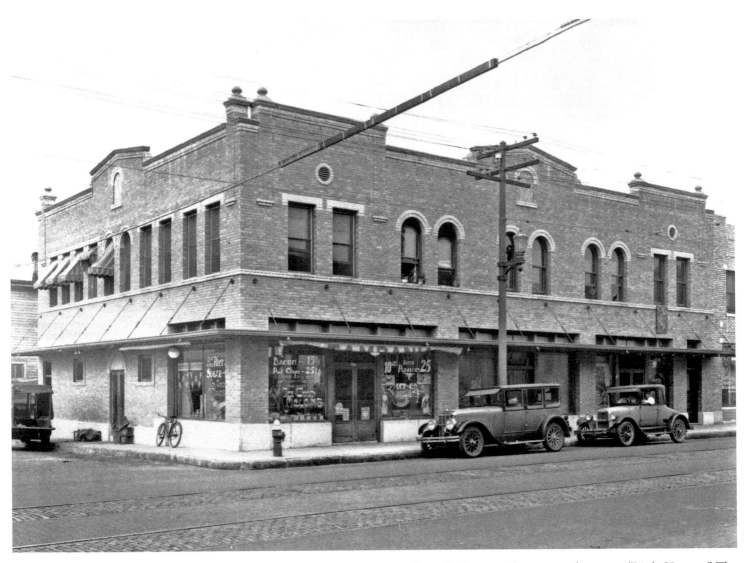

The A. Cappello & Brother Grocery Store on West Fortune Street in the part of town once known as "Little Havana." The two-story building was a grocery downstairs and residential apartments above.

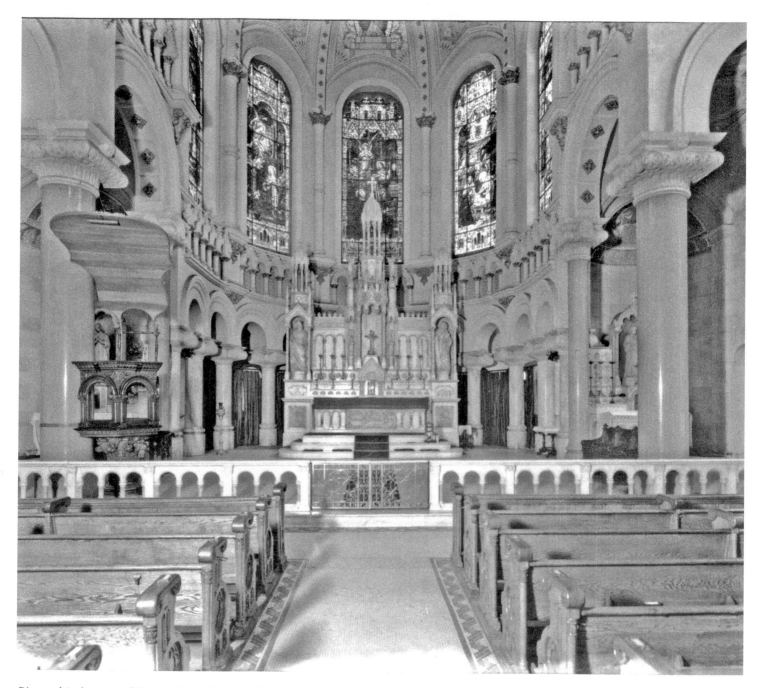

Pictured is the apse of Sacred Heart Catholic Church on Florida Avenue. The 1931 view reveals the marble altar and magnificent stained-glass windows. Sacred Heart was built in 1905.

In this 1932 publicity stunt, an American Austin Roadster was driven up the steps of the Post Office on Florida Avenue.

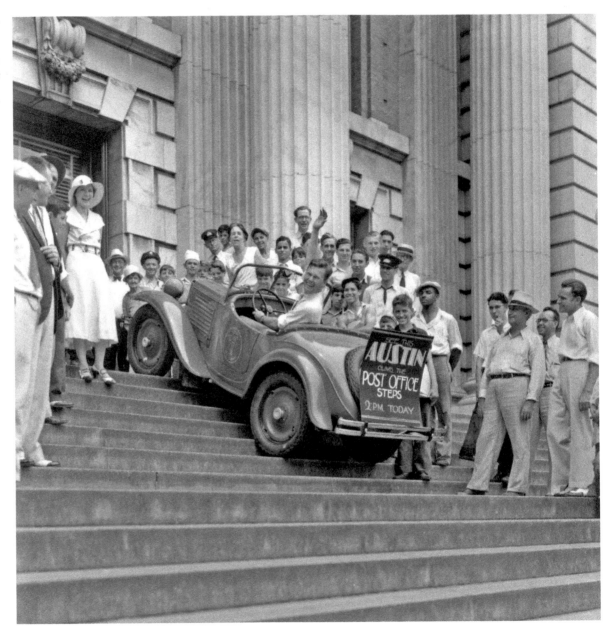

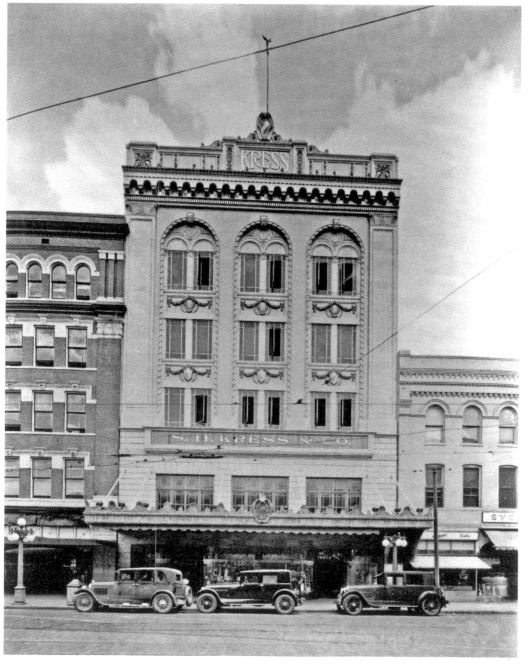

The S. H. Kress & Company between Franklin Street and Florida Avenue. The Kress store, which is on the National Register of Historic Places, has terra cotta facades and a bronze marquee. Samuel Kress, the founder of the five-and-dime store chain, was an art collector and took great pride in building architecturally pleasing stores.

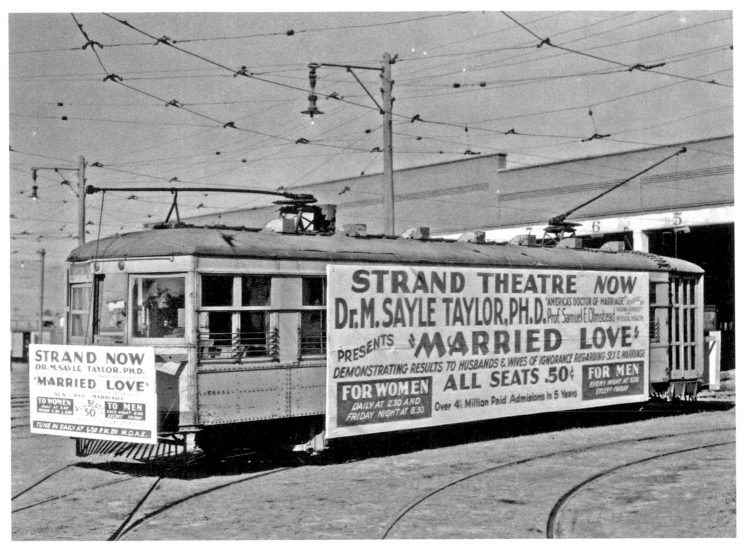

A placarded streetcar advertising marriage counseling seminars at the Strand Theatre is pulling away from the station house. Notice that women and men attend separate sessions.

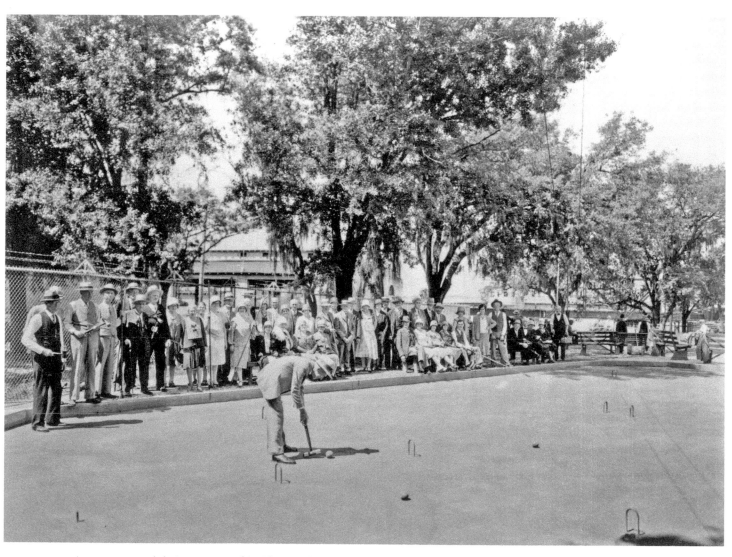

A croquet match being contested in Plant Park, next to the Tampa Bay Hotel. This photograph, taken in 1930, was shot three years before the vacant landmark hotel was reopened as the University of Tampa.

Miss Florida 1931 makes a promotional appearance at the Joyland Silver Dome on Clearwater Beach, on the Gulf Coast of Pinellas County.

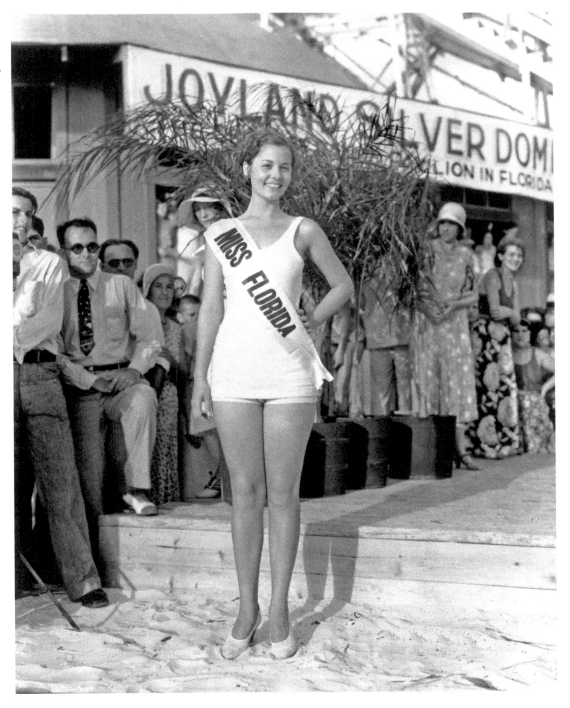

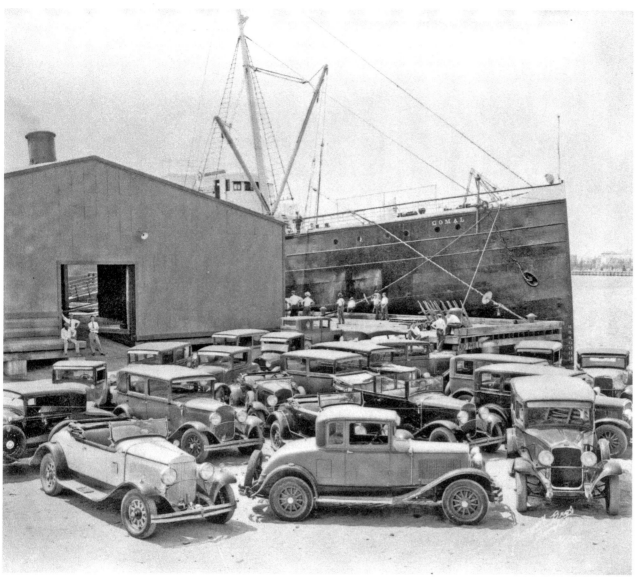

A shipment of new cars received at the Mallory Dock in the Port of Tampa in 1930. The vehicles were destined for the R. S. Evans new and used car dealership on Florida Avenue in the Hulsey Building.

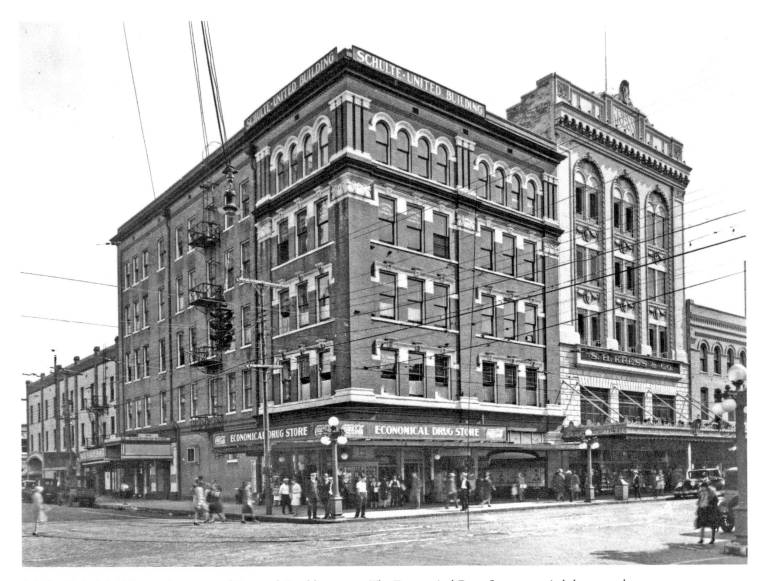

Schulte-United Building at the corner of Cass and Franklin streets. The Economical Drug Store occupied the ground floor of the Schulte-United.

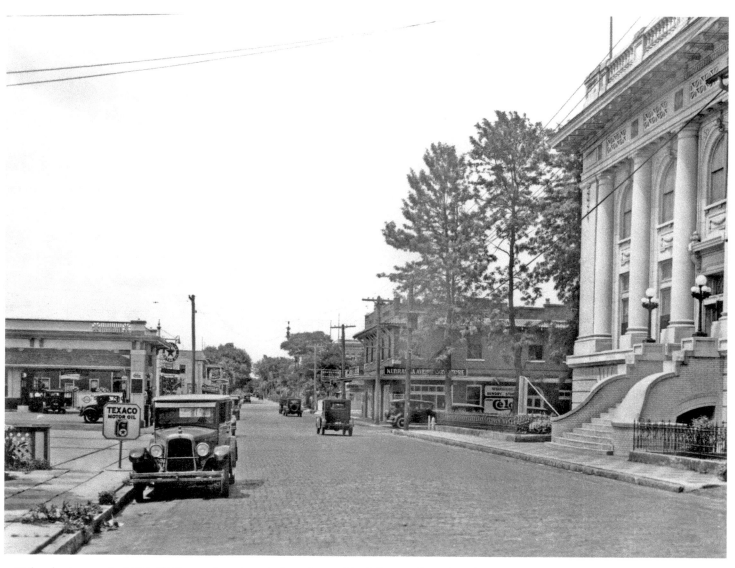

Nebraska Avenue in 1931. El Centro Asturiano is the columned building on the right side of the photo. A Texaco service station is to the left.

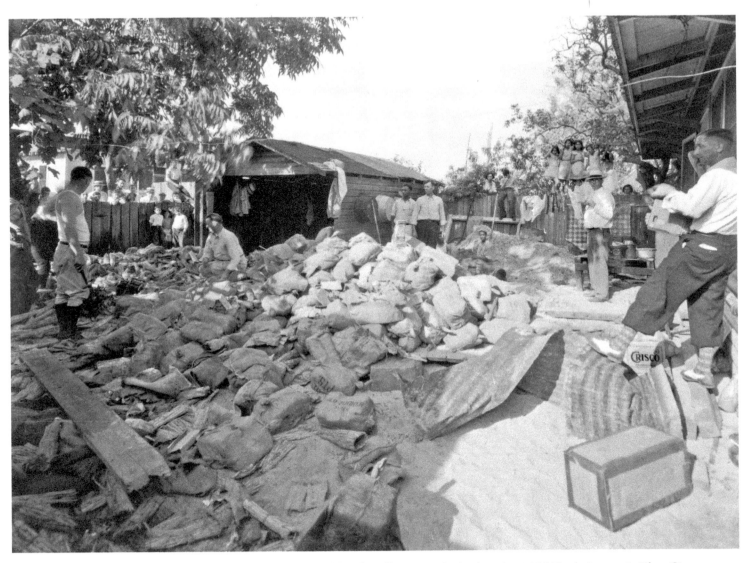

In 1931, during Prohibition, federal authorities dig up bagged bottles of liquor in the backyard at 1014 Tenth Avenue in Ybor City.

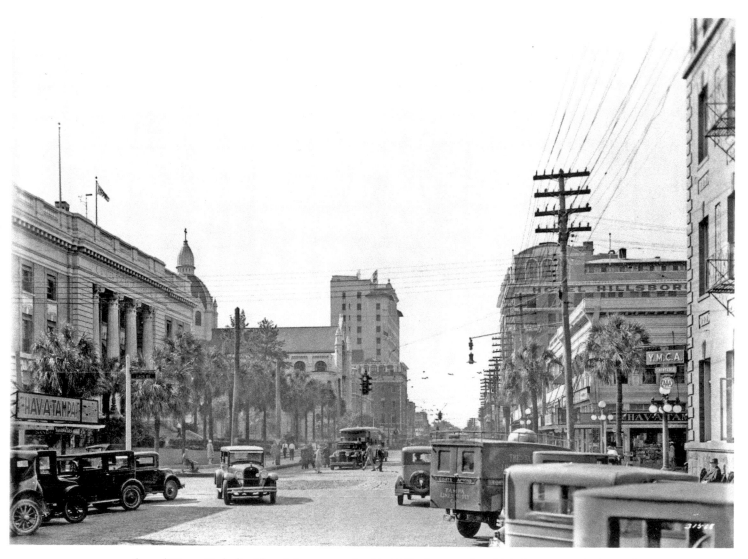

Sacred Heart Catholic Church is at center in this 1930 photograph, which focuses south down Florida Avenue. The tall building beyond is the Tampa Terrace Hotel.

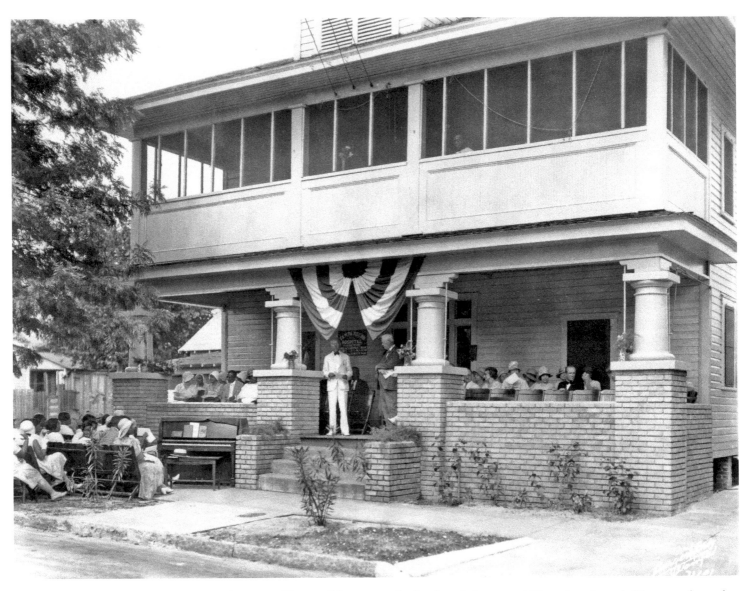

The dedication of Tampa Negro Hospital in 1923. The small house was the first hospital to treat African-Americans in Tampa and was the result of the tireless efforts of Clara Frye. It is noteworthy that the guests at the ceremony are segregated, whites on the right and blacks on the left.

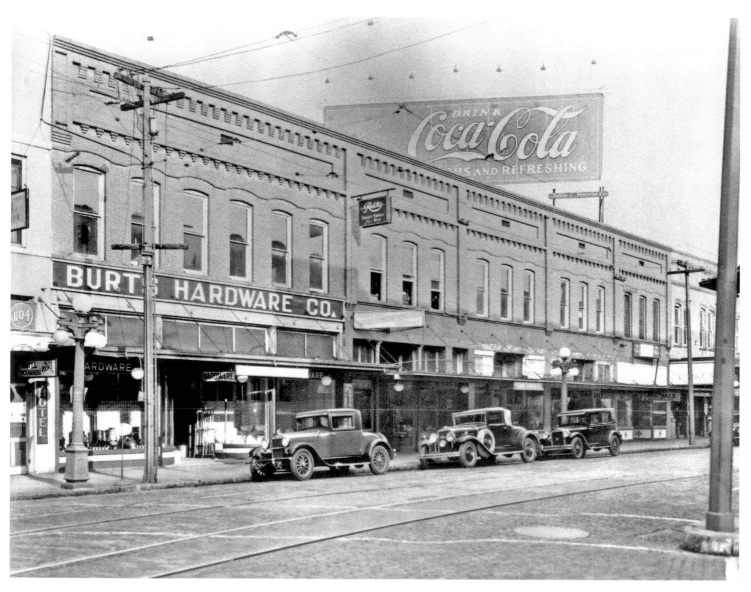

A 1930 view of Franklin Street featuring Burt's Hardware and Vicker's Printing Company.

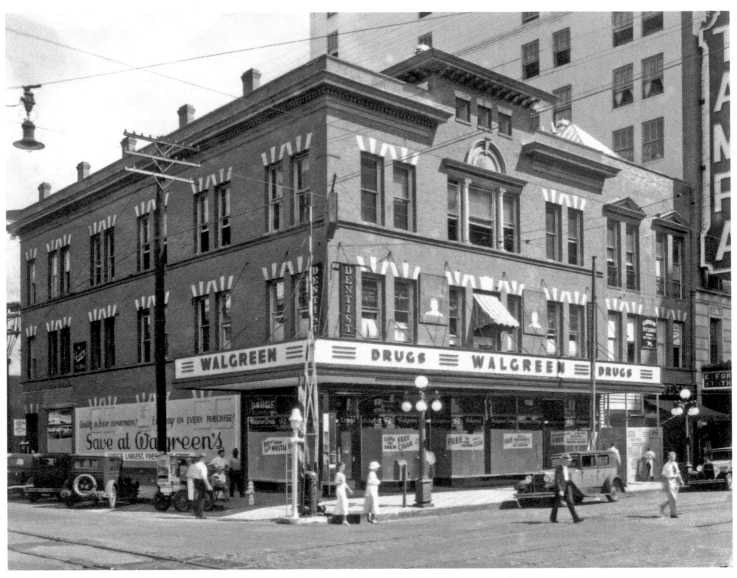

Walgreen's Drug Store at the corner of Franklin and Polk streets in October 1934. The sign for the Tampa Theatre is visible at far-right.

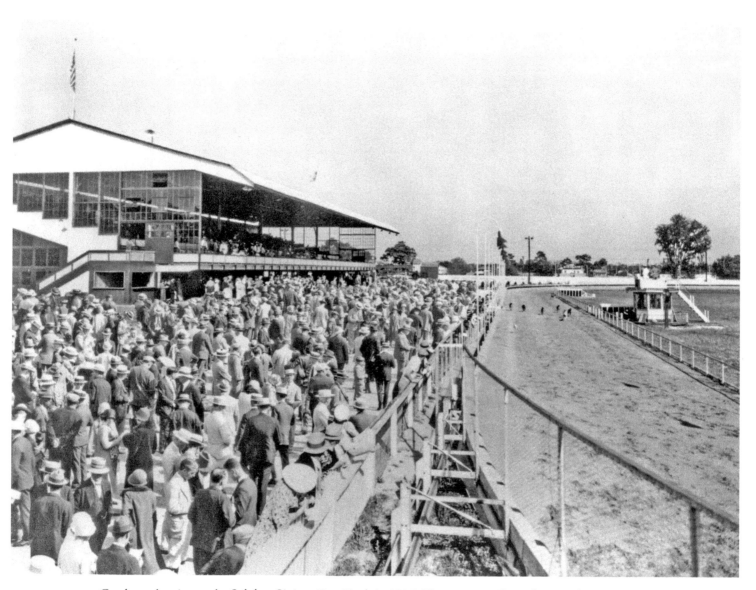

Greyhound racing at the Sulphur Springs Dog Track in 1935. The quarter-mile track opened in January 1921. The winner of the very first race was Royal Mae.

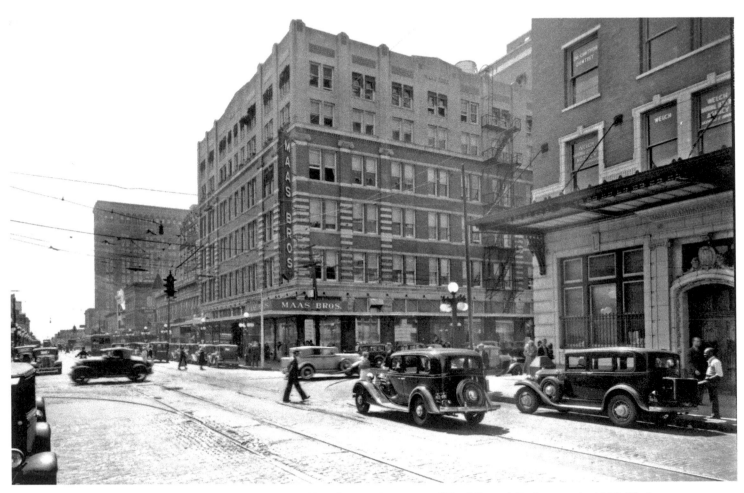

The Maas Brothers moved their store into the Krause Building here at the corner of Franklin and Zack streets in 1898. Their store remained there until the American National Bank was built.

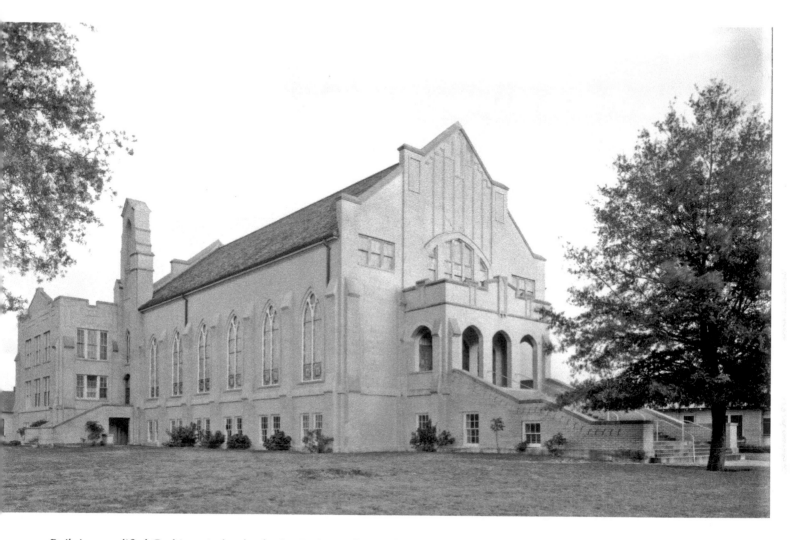

Built in a modified Gothic revival style, the Seminole Heights Methodist Church was built in 1927 and is pictured here in 1935. The church, which has been extensively restored, is located at the corner of Central Avenue and East Hanna.

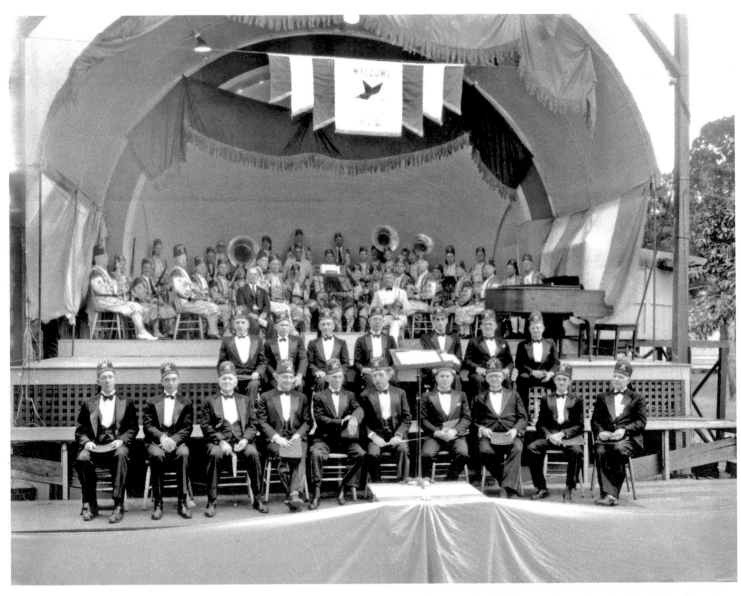

This 1934 photograph features chanters and orchestra of the Egypt Temple. At that time the facility was located at 402 South Boulevard.

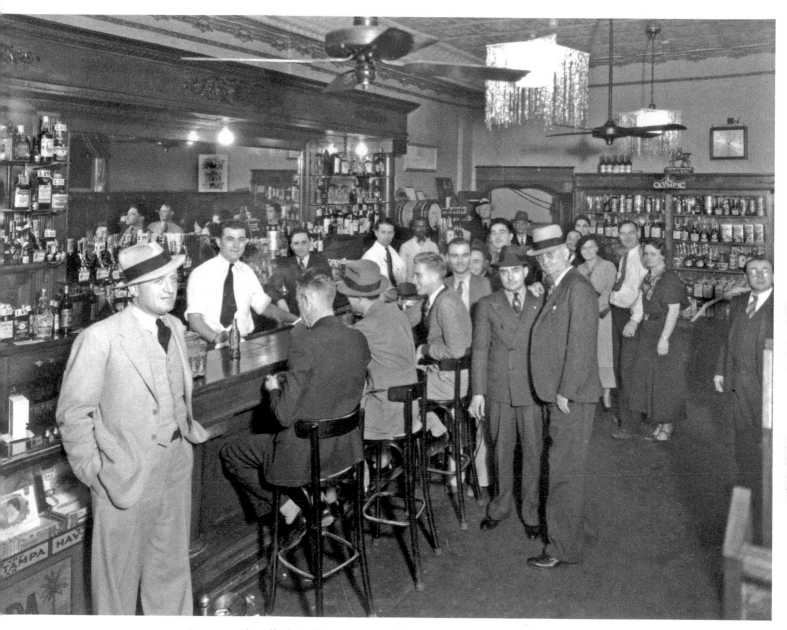

Patrons and staff of the Olympic Bar at the corner of Cass and Tampa streets in 1936. The well-stocked bar includes fine Tampa-rolled cigars (at left).

The Tampa Bay Hotel, which had closed in 1905, remained unused until the University of Tampa took up residence in 1933. This photograph, taken in 1936, is outside of what was the main lobby of the hotel, now known as Plant Hall.

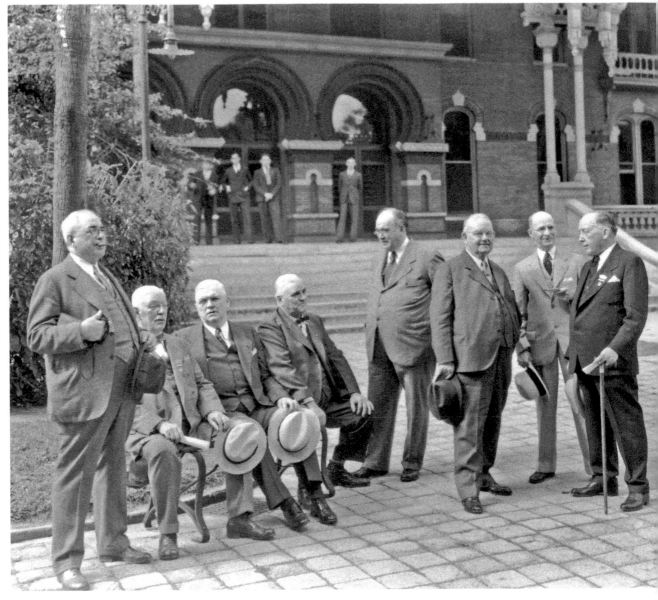

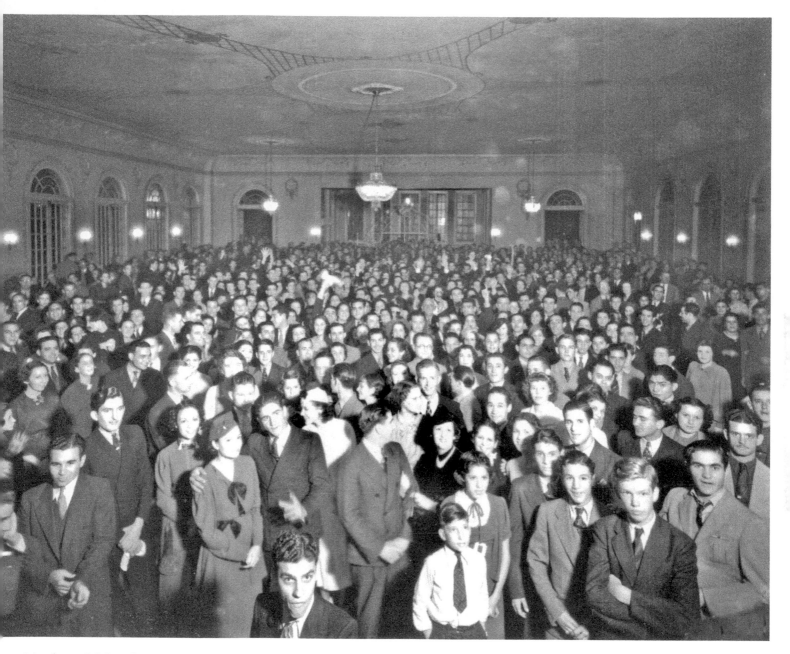

Members of el Circulo Cubano (the Cuban Club) with their families in the elegant ballroom. The Cuban Club was a massive four-story building with a wide range of amenities. This social club was formed circa 1900.

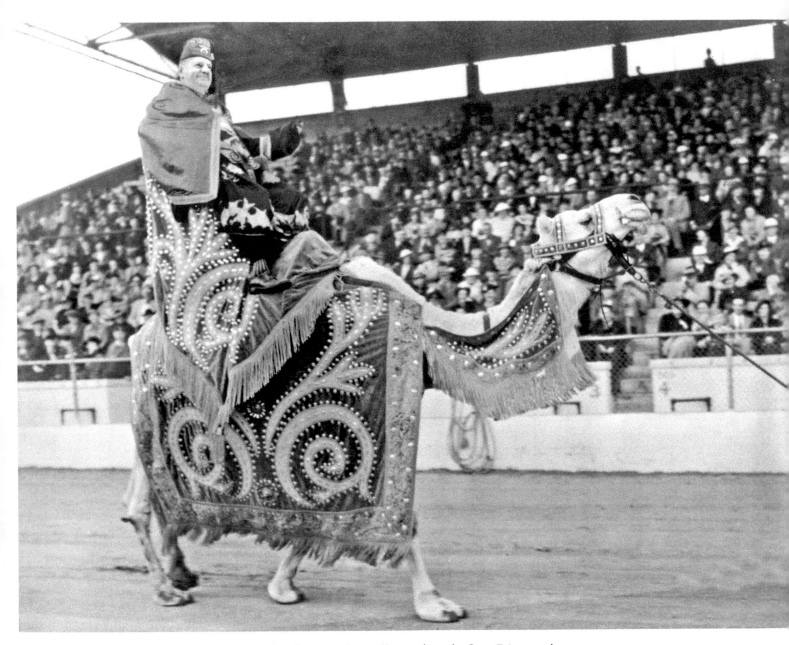

Bill Blocks, in Masonic regalia, rides a camel in the 1938 Gasparilla parade at the State Fairgrounds.

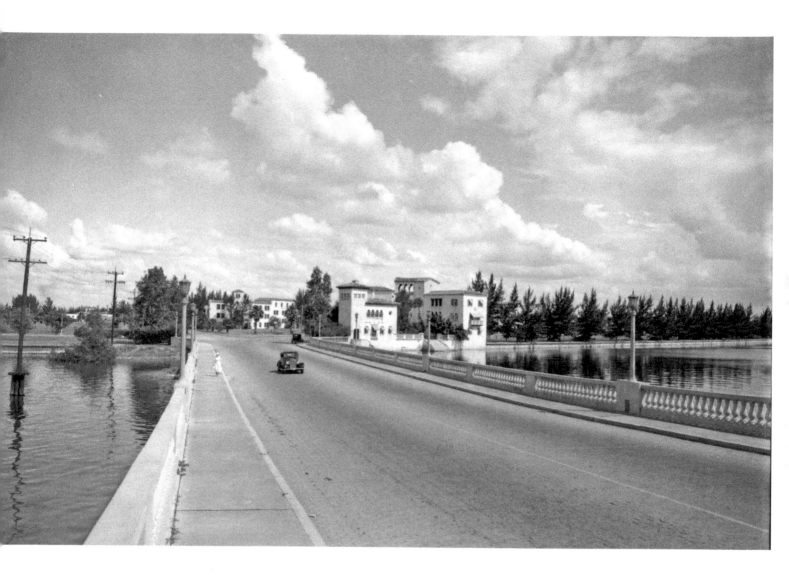

Pedestrian and automobile traffic over the original bridge that connected Davis Islands with Bayshore Boulevard.

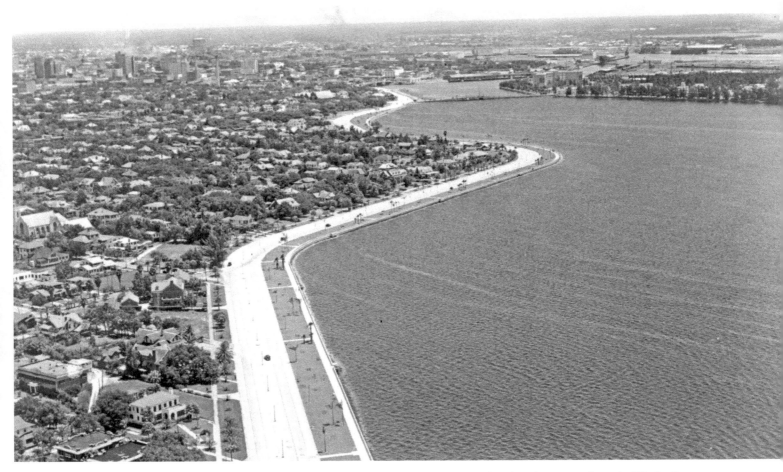

An aerial view of Bayshore Boulevard after the restoration and widening that was completed under grants from the Works Progress Administration, a federal New Deal program supported through tax dollars that employed out-of-work Americans during the Great Depression. Bayshore was substantially damaged by a hurricane in October 1921. The refurbished and repaired road was four lanes with a median and street lights.

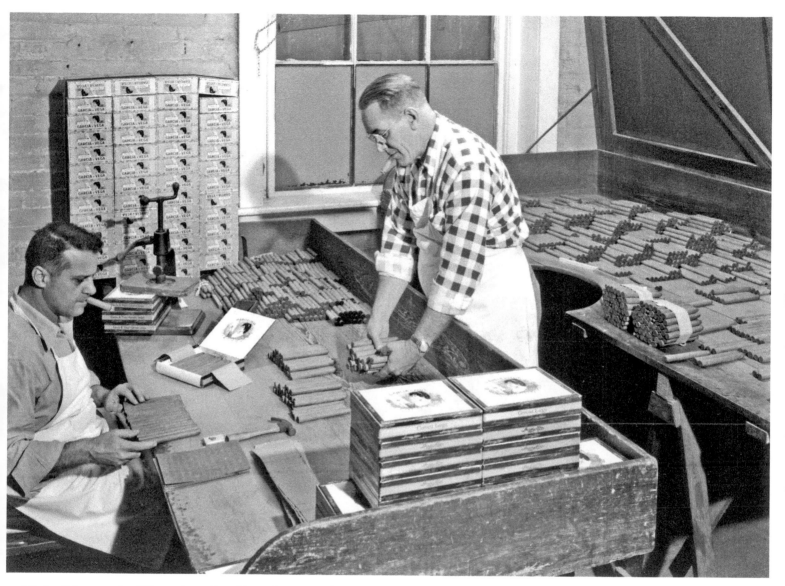

Much of the growth of Tampa is attributable to the cigar industry. By 1958, however, the industry in Tampa held a mere fraction of its once grand stature. Here, two workers are hand packaging Corona Largas at the Garcia y Vega factory.

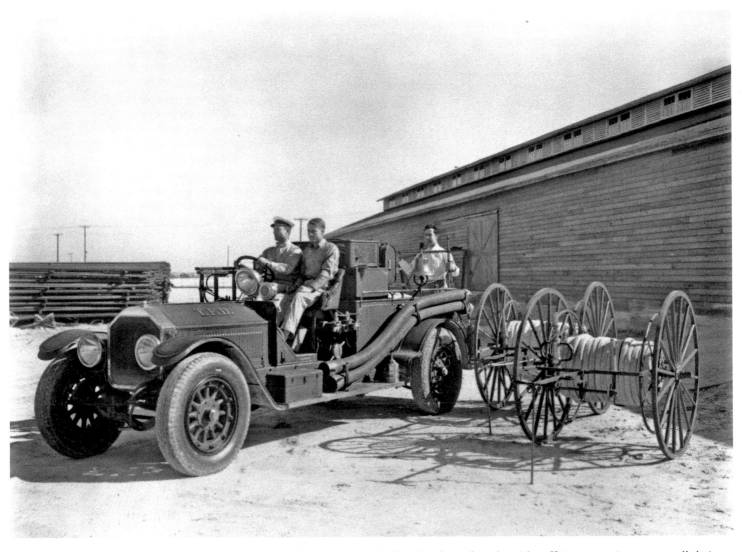

Fire fighters of Tampa Fire Department are ready to roll out to a blaze. Before the days of trucks with sufficient capacity to carry all their own stores, extra equipment such as the hose carriages seen here was towed to the fire.

World War II and the Baby Boom

(1940–1959)

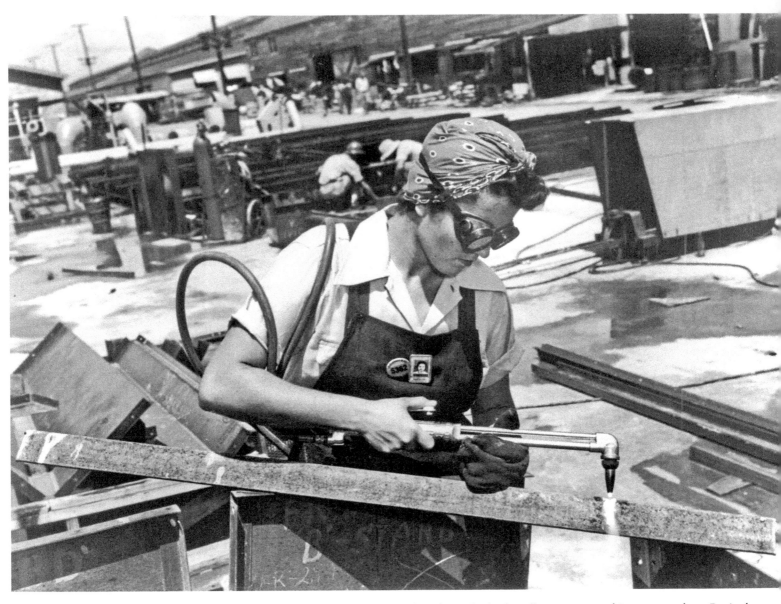

During World War II there were nearly 31,000 shipyard workers who built well over 100 warships, among them Rosie the Riveter. By the end of the conflict, women were commonplace in all manner of jobs in the yards. Along the way, union membership rules had to be changed to allow for women in their ranks.

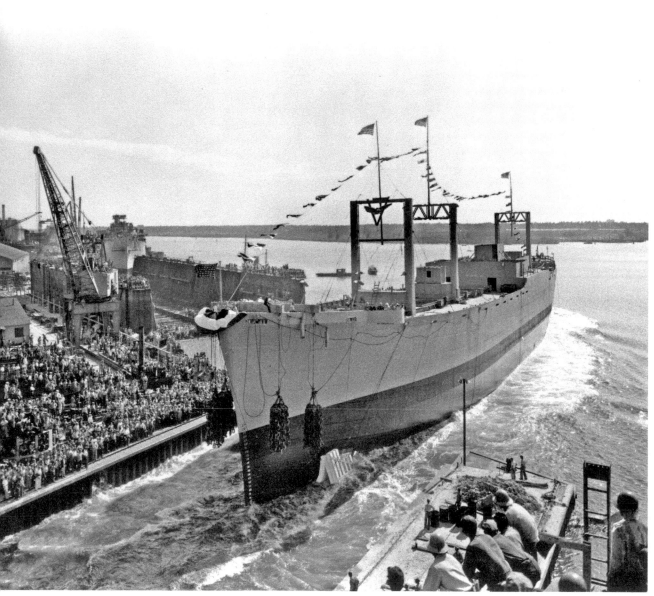

Through World War II, Tampa's shipyards made significant contributions to the United States war effort. This is the launch of the USS *Mauna Loa* from Port Tampa City in 1943. Port Tampa remained a separate city until annexed in 1961.

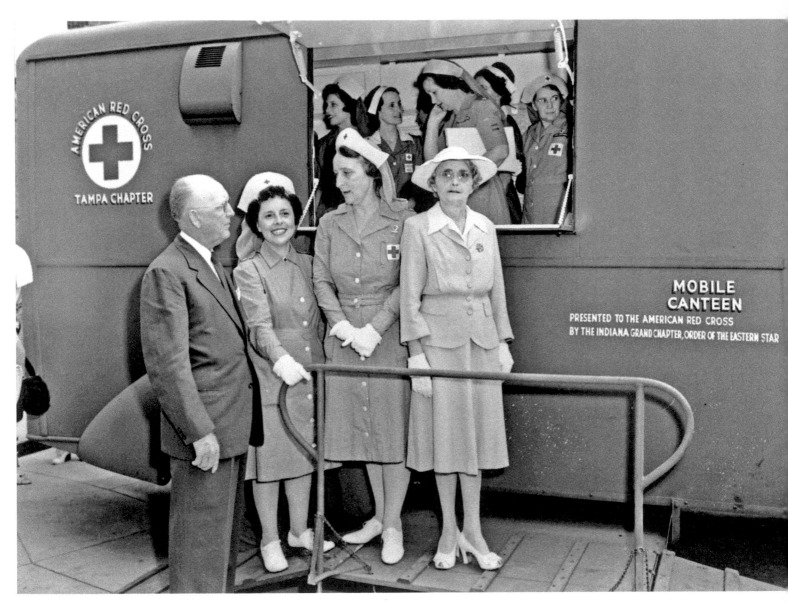

Volunteers of the Tampa Chapter of the American Red Cross inspect a Mobile Canteen vehicle donated by a sister chapter from Indiana. (1943)

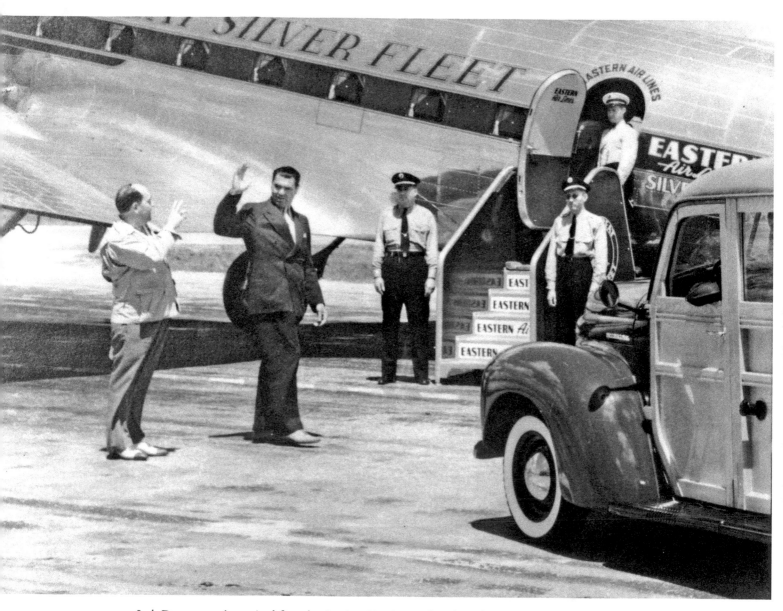

Jack Dempsey, who retired from boxing in 1927, is seen here boarding an Eastern Airlines plane at Drew Field, likely sometime after his World War II service in the Coast Guard. Dempsey once fought an exhibition in Tampa for a real estate developer of the Forest Hills subdivision.

This image of the First Christian Church is from 1943. The sanctuary, located at 350 Hyde Park Avenue, was built in 1922.

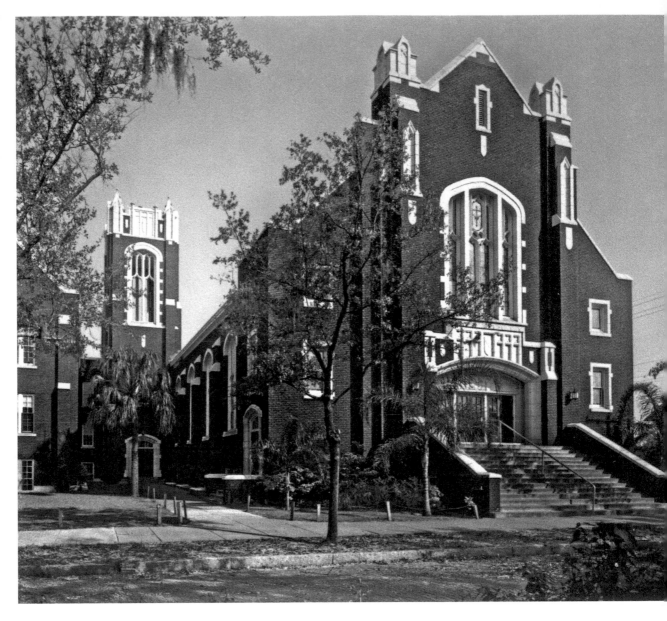

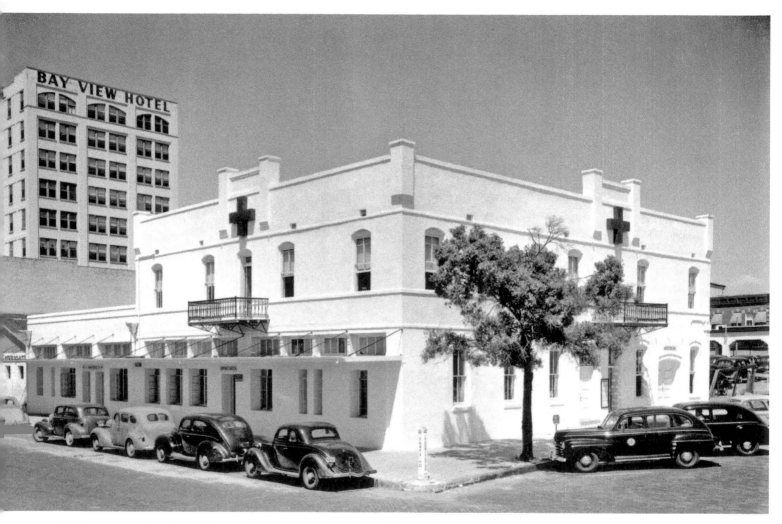

The building occupied by the Tampa Chapter of the American Red Cross as it appeared in 1946. This building was on the 200 block of Tampa Street.

Cigar makers at their rolling tables at the Cigar Manufacturer's Association on East Lafayette Street. This photo was taken in November 1946 as the industry was becoming mechanized. Nonetheless, there is nothing so fine as a hand-rolled cigar made by a true craftsman.

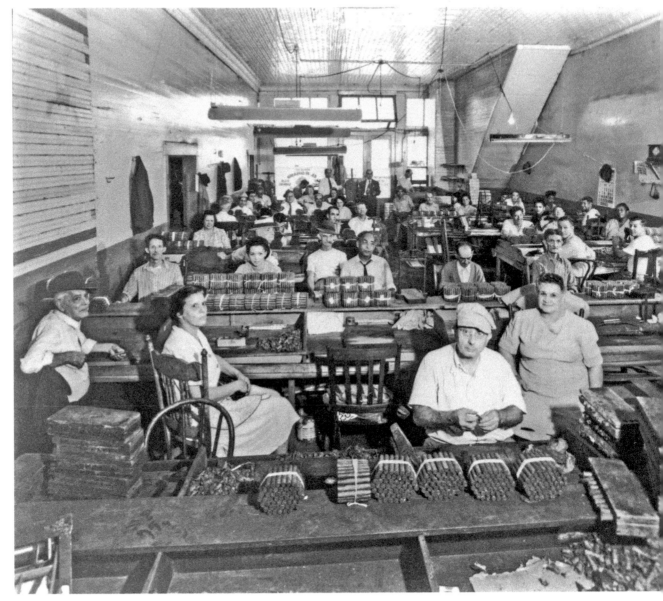

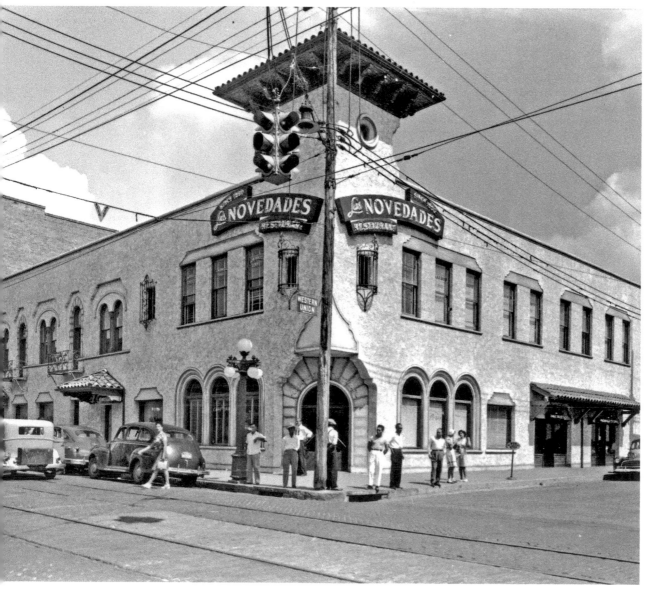

Las Novedades Restaurant was founded by Manuel "Canuto" Menendez at the corner of Seventh Avenue and Fifteenth Street. Las Novedades means, "The Novelties." This was an extremely popular place to dine, so much so that in 1898 a squad of Rough Riders rode their horses right into the dining room. They were greeted warmly. (1946)

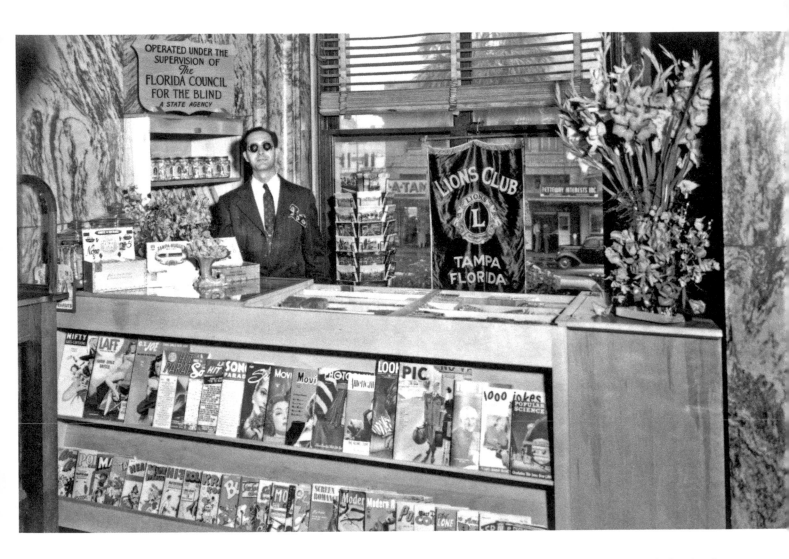

The newsstand in the Federal Building in 1946. The stand was operated by the Lions Club of Tampa in association with the Florida Council for the Blind. Cigars are for sale on the countertop.

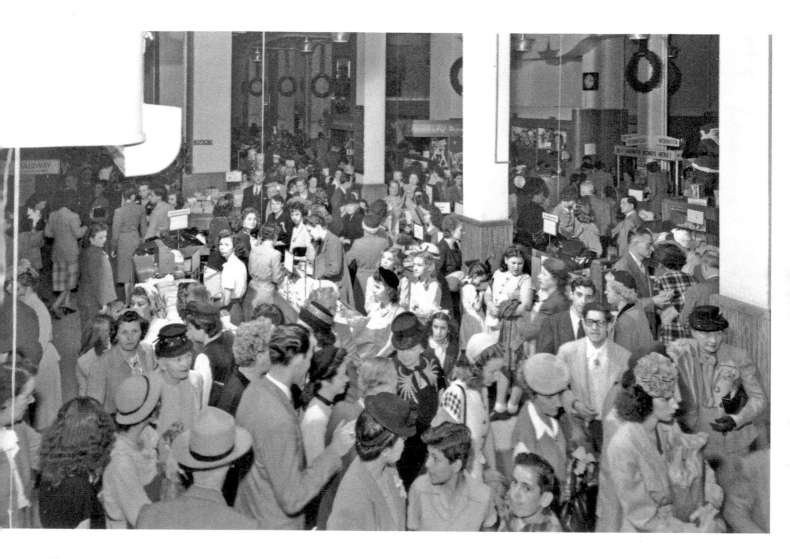

Abe Maas moved to Tampa and opened his first store, the Dry Goods Palace, in 1886. Later that same year his brother, Isaac, joined him and they opened the first Maas Brothers store. This is the main floor of their downtown location in 1946.

The Neoclassical styling of the
International Bank at the corner of
West Fortune and Spring streets in
downtown Tampa.

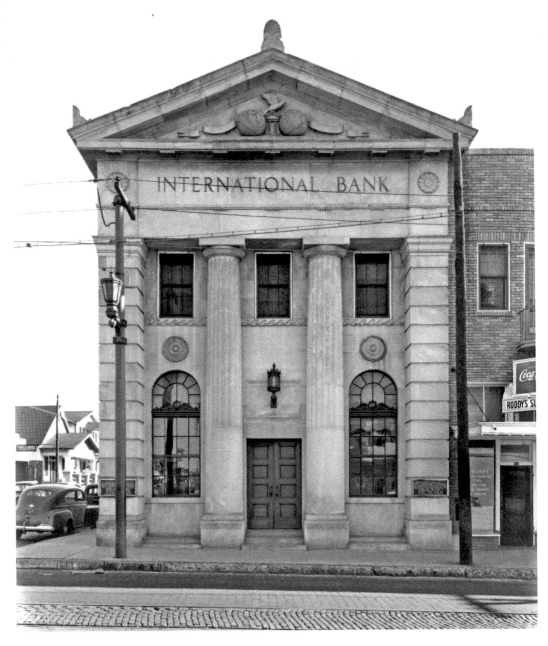

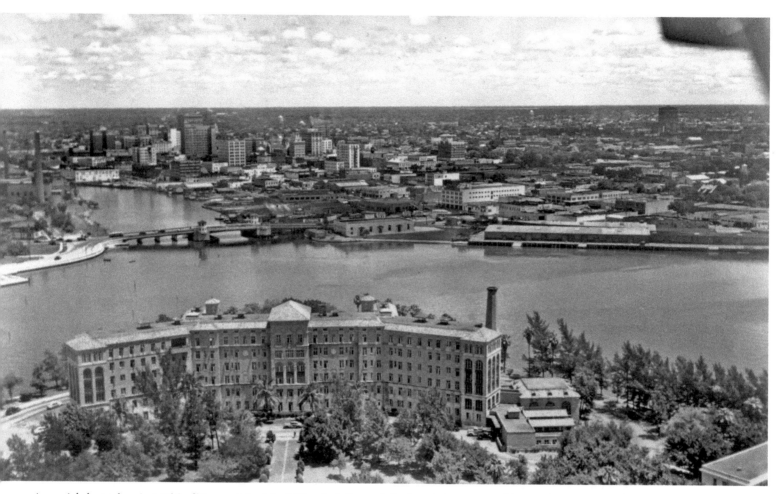

An aerial shot taken in 1946 of Tampa Municipal Hospital. Beyond the hospital compound is the Platt Street Bridge crossing the mouth of the Hillsborough River. The landmark dome of the Hillsborough County Courthouse and the clock tower of City Hall are visible downtown.

Stevedores unload a shipment of bananas at the Port of Tampa. According to the photographer, many other goods passed through the port, but bananas seemed especially picturesque. (1947)

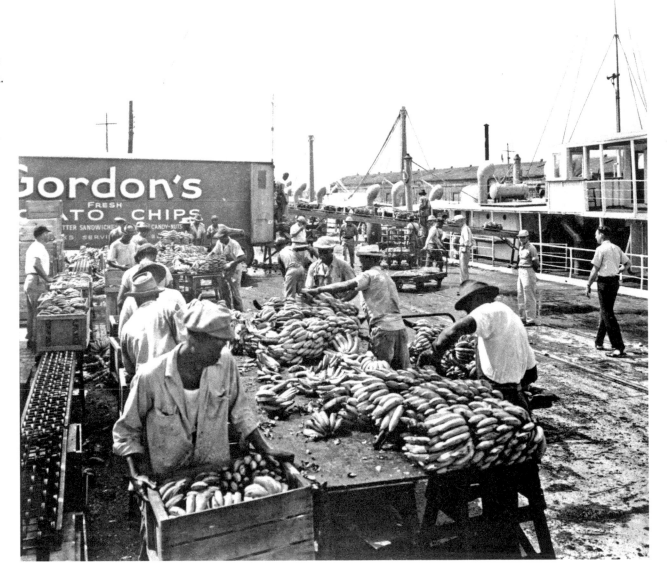

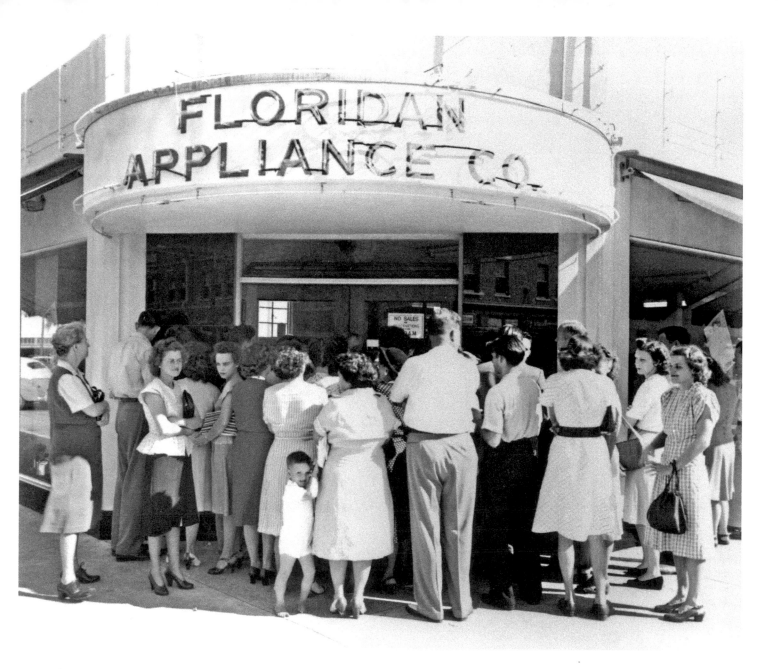

A crowd awaits the opening of the Floridan Appliance Company store on East Cass Street. (1943)

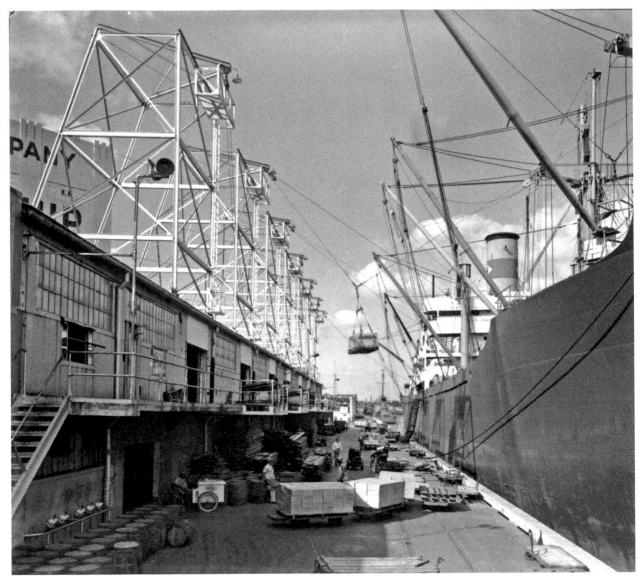

A 1948 view of the Gulf Florida Terminal at the Ybor Channel. The freighter, *Bessemer Victory*, is being loaded with fruit juice.

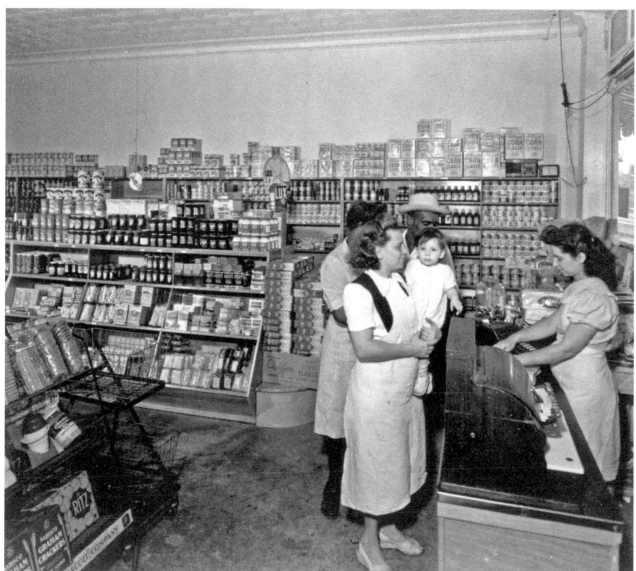

Customers and clerk in the Floridan Grocery Store on Main Street in West Tampa. The Floridan businesses were named for the principal artesian aquifer that provides water to the region.

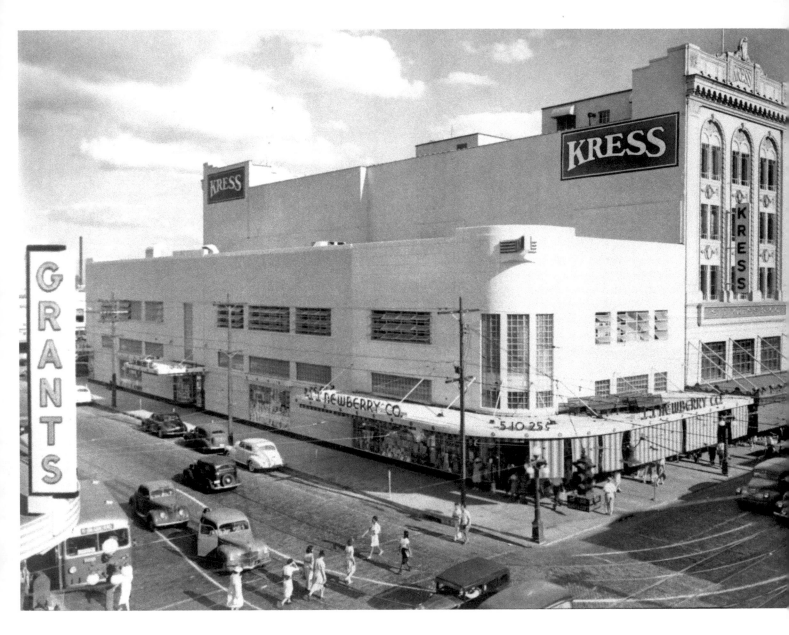

The Art Deco styled J. J. Newberry Company on the corner of Cass Street, looking south down Franklin Street. The S H Kress facade and signs are right next door.

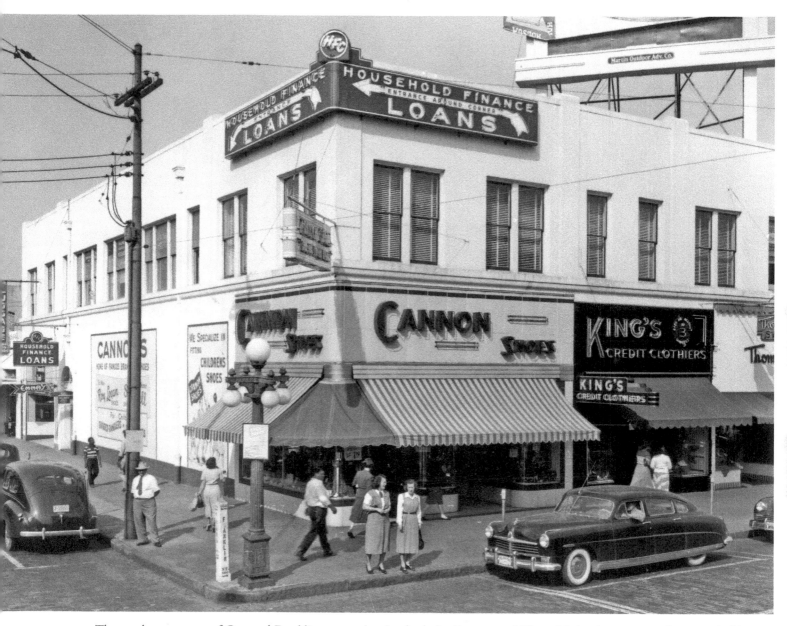

The northwest corner of Cass and Franklin streets, showing both the Cannon and Thom McAn shoe stores and a Household Finance Loan office. (1949)

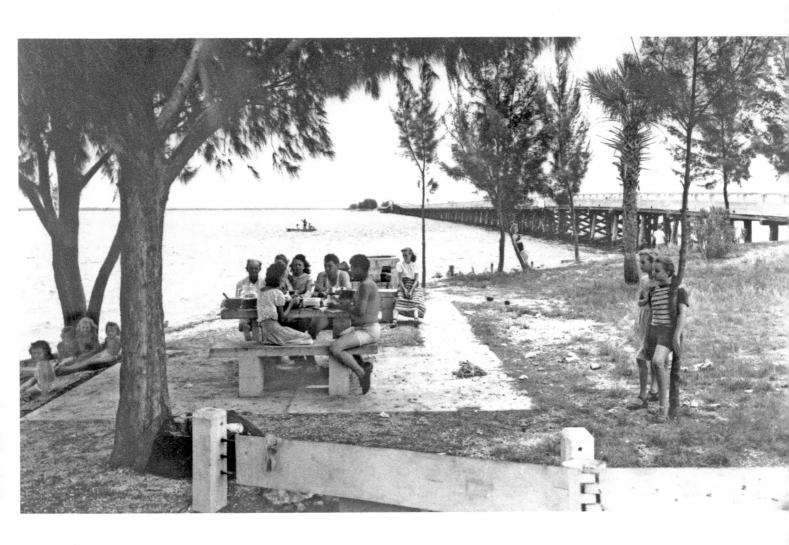

The bridge in the background spanned Old Tampa Bay from Tampa to Clearwater. The bridge was started in 1927 by Ben T. Davis but halted by the 1927 economic crash in Florida and further hampered by the Great Depression. The bridge was completed in 1934 through federal recovery program grants. Beautification of the causeway followed World War II, adding picnic areas and public beaches. The man receiving credit for the enhancements was Courtney Campbell. The causeway bridge now bears his name.

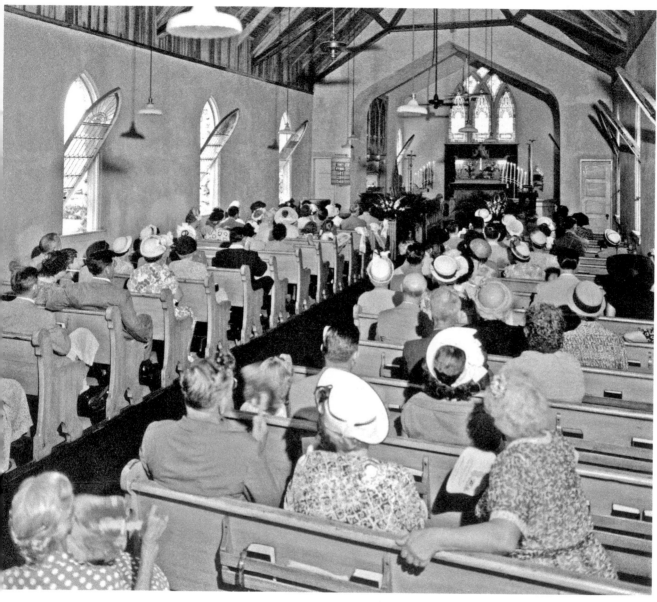

A photograph of a wedding ceremony in 1950 at the Episcopal House of Prayer on East Columbus Drive in West Tampa. In the days before air conditioning, these stained-glass windows pivoted for ventilation.

This image of the Hillsborough County Courthouse was shot the same year the new, replacement courthouse building was completed. The thoroughfare in front of the building is Franklin Street. The Civil War Memorial is visible in the diagonally cut sidewalk from the corner of Franklin and Lafayette up to the steps of the courthouse.

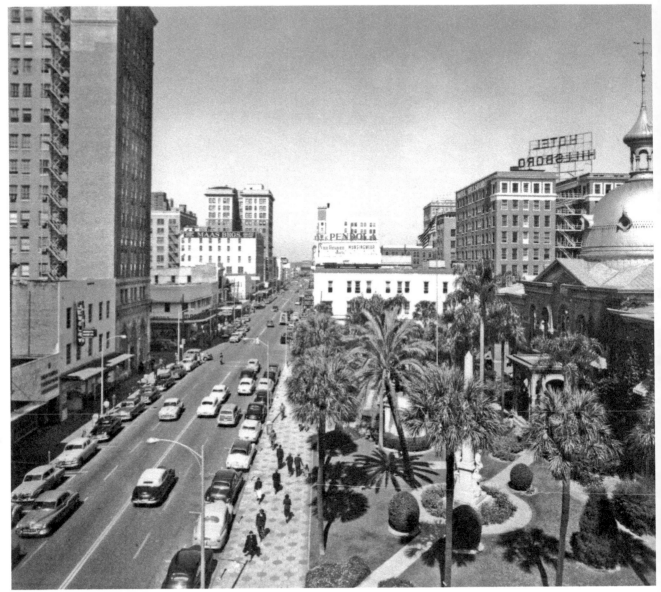

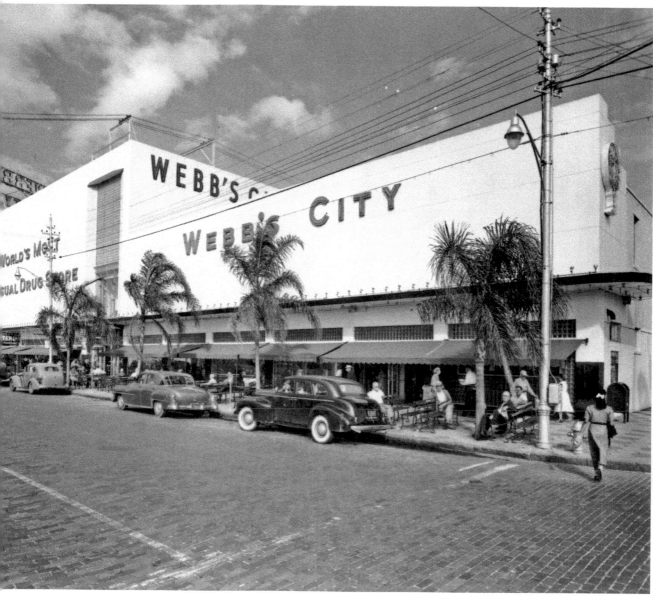

In 1925, James "Doc" Webb bought into a small drugstore. During the Great Depression, as other stores closed down Doc Webb bought the additional space. Eventually he had more than 70 stores and had 1,200 employees. Doc Webb's son, Jim, asserts credit for inventing the "10 Items or Less" check-out line.

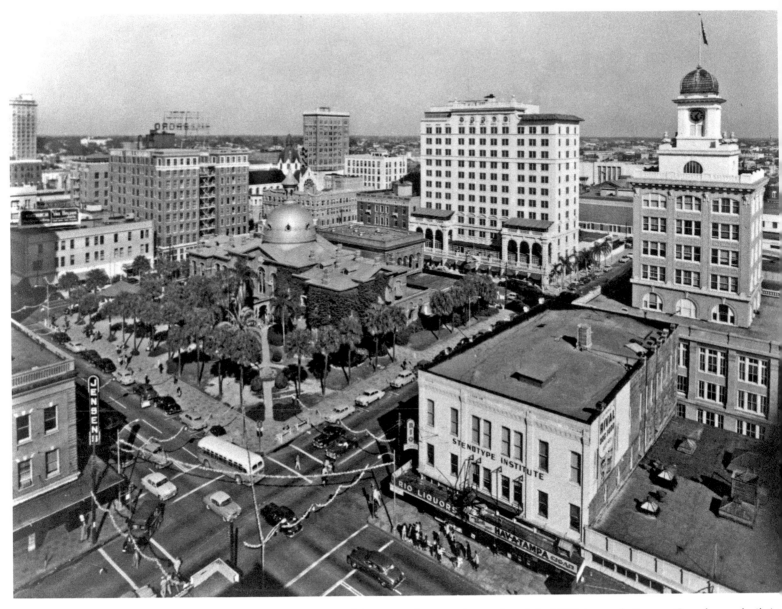

The domed building in the center of this 1952 photograph was the original Hillsborough County Courthouse, built in 1891. To the right is Tampa City Hall. Behind the courthouse is the Tampa Terrace Hotel.

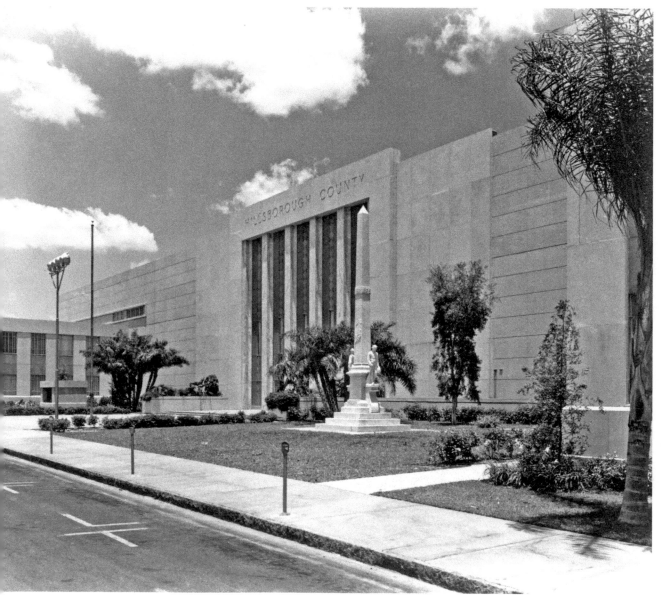

The Civil War Memorial in front of the new Hillsborough County Courthouse. The memorial was moved here in 1952 when the building was completed. The monument initially stood on the ground of the old courthouse building at Lafayette and Franklin streets. The memorial, titled Memoria In Aeterna, was a gift in 1911 from United Daughters of the Confederacy.

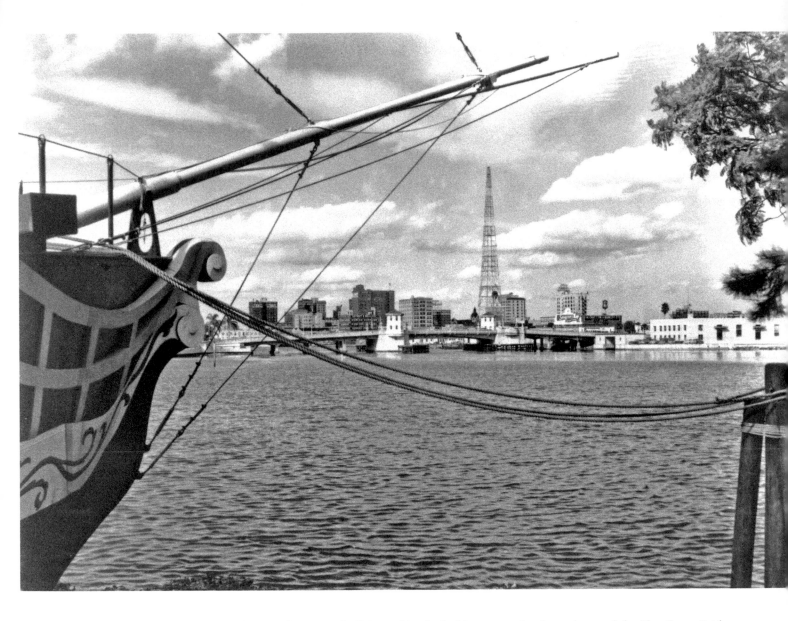

The pirate ship of Ye Mystic Krewe of Gasparilla, moored off Davis Islands, looking across the channel toward the Platt Street Bridge.

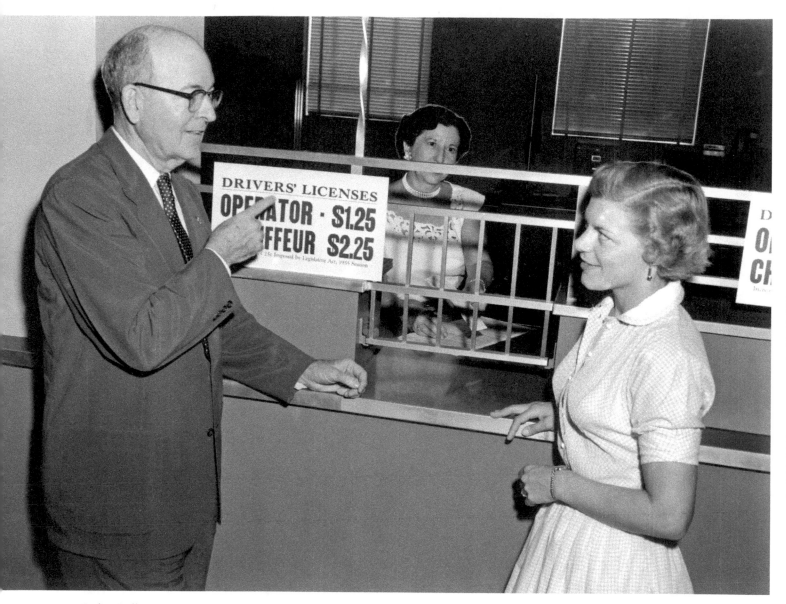

Judge William C. Brooker poses with a customer at the Auto License Bureau. The clerk, behind the counter in this 1955 image, looks on in her lovely business attire.

The City Hall building was constructed in 1915 of brick and granite. It sits at the corner of Lafayette (now Kennedy) and Florida Avenue. The clock tower, known as Hortense, was a donation of the W. H. Beckwith Jewelry Company.

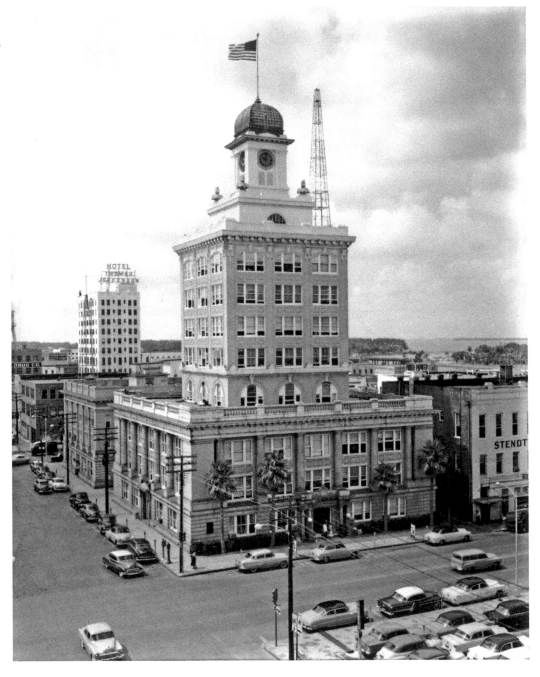

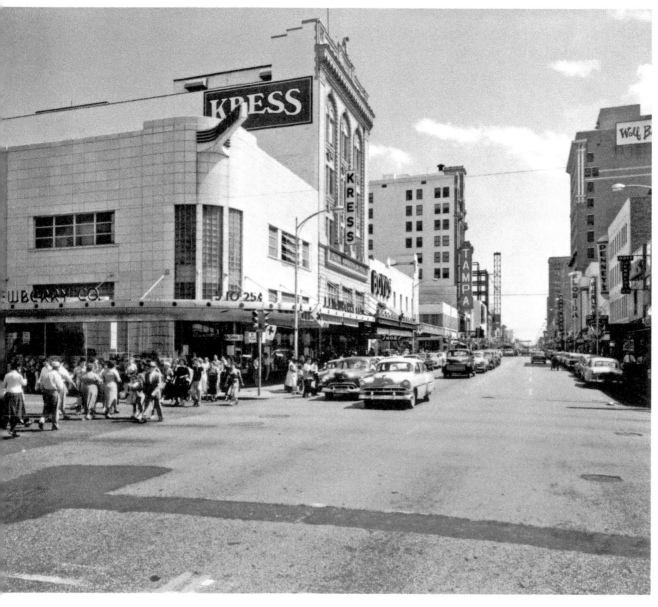

J. J. Newberry Company and S. H. Kress & Company, both five-and-dime stores, were located in the 800 block of North Franklin. They are visible here from the Cass Street intersection.

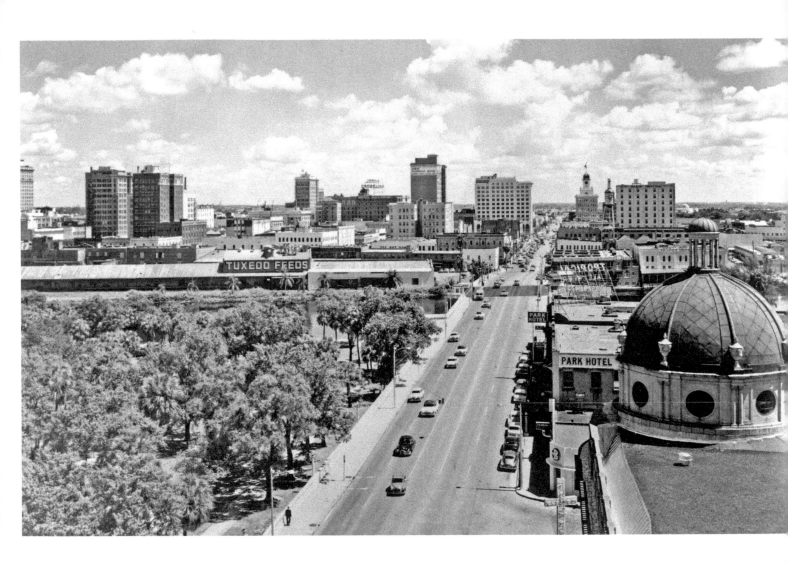

A view east on Lafayette Street. In the foreground to the left is Plant Park and to the right is the dome of the First Baptist Church. Across the river, the cupola and flag mast of City Hall is visible. The "Tuxedo Feeds" sign is on the Atlantic Coast Line Railroad warehouse along the river. (1955)

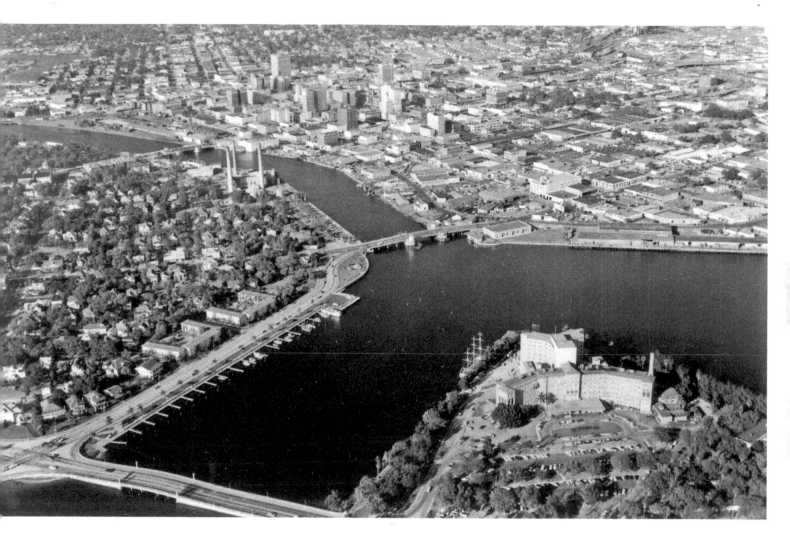

This aerial view from 1957 shows the Hillsborough River (top left) opening to Garrison and Sutton channels. The span in the foreground is the original Davis Islands Bridge and the perpendicular road is Bayshore Boulevard. Tampa General Hospital is the large complex on the tip of Davis Islands.

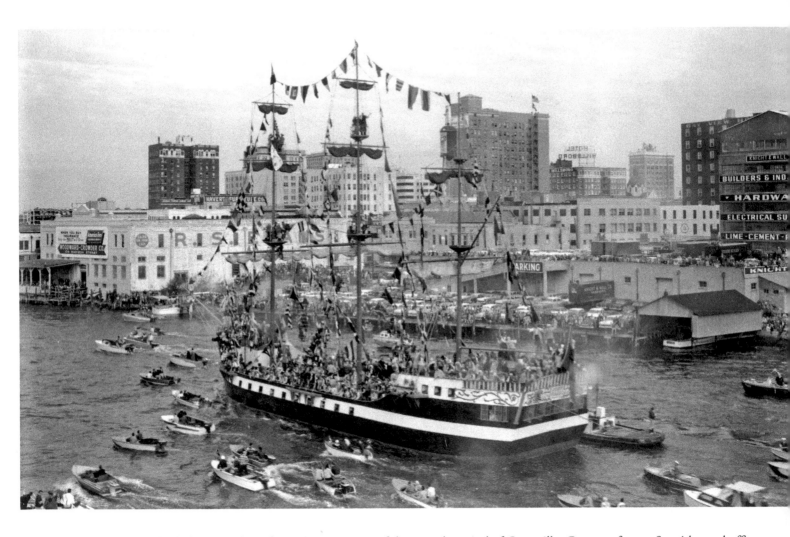

Pleasure boaters flank the pirate ship of José Gaspar as part of the annual carnival of Gasparilla. Gaspar, a former Spanish naval officer, never actually invaded Tampa, but he was an actual pirate. He and his crew sailed and terrorized shipping interests along the south Florida coast in the late eighteenth century.

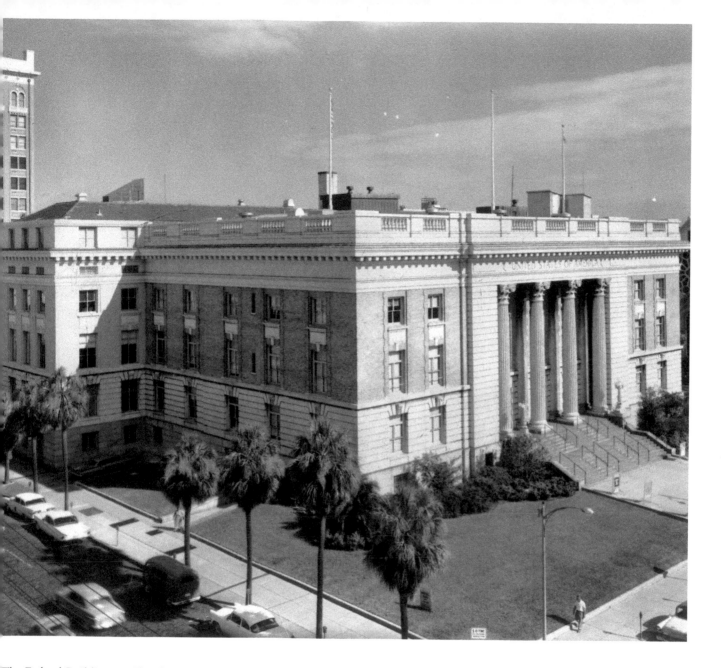

The Federal Building on Florida Avenue in 1960. The tall building to the left of the frame is the Floridan Hotel. To the far right is Sacred Heart Catholic Church.

The Post Office shares space in the Federal Building on Marion Street. The loading dock of the Post Office is visible in the foreground. The taller of the two buildings on past the Federal Building is the Citizen's Bank Building.

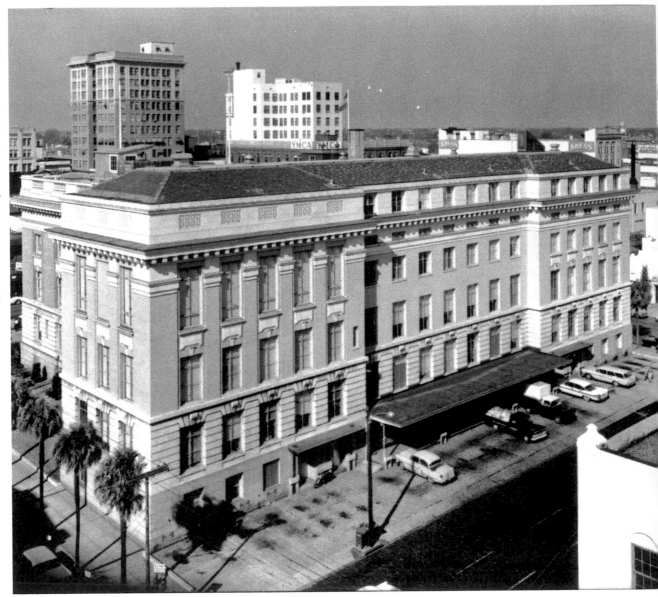

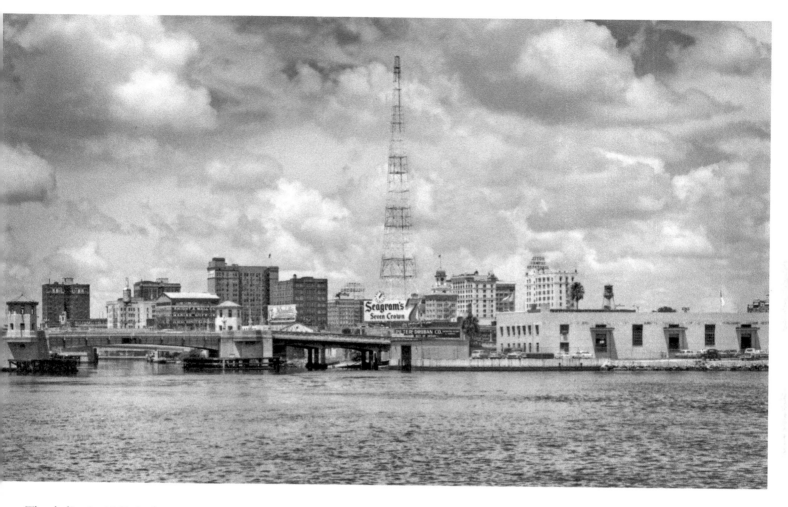

The skyline in 1960, looking across Garrison Channel at the Platt Street Bridge and toward the mouth of the Hillsborough River from the vantage of Davis Islands.

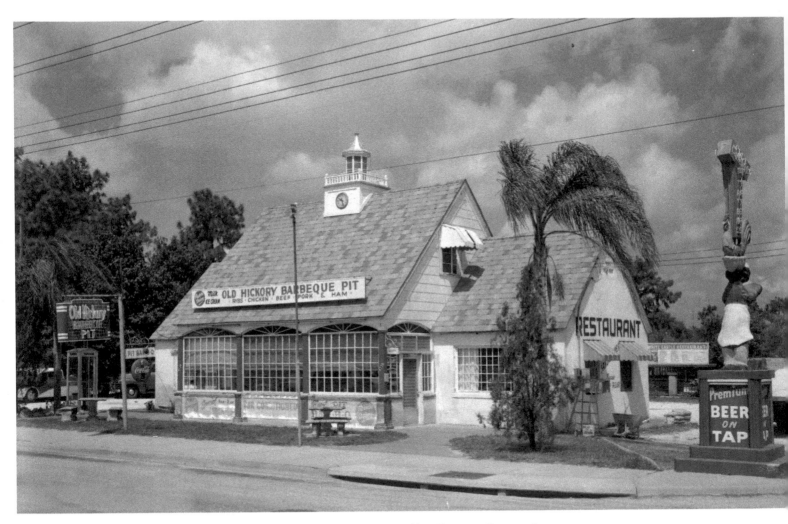

The Old Hickory Barbeque Pit on East Hillsborough Avenue, operated by Christian Ostegaard.

NOTES ON THE PHOTOGRAPHS

These notes, listed by page number, attempt to include all aspects known of the photographs. Each of the photographs is identified by the page number, a title or description, photographer and collection, archive, and call or box number when applicable. Although every attempt was made to collect all data, in some cases complete data may have been unavailable due to the age and condition of some of the photographs and records.

Printed in the USA
CPSIA information can be obtained
at www.ICGtesting.com
JSHW072026140824
68134JS00042B/3797